Van Gogh in Arles

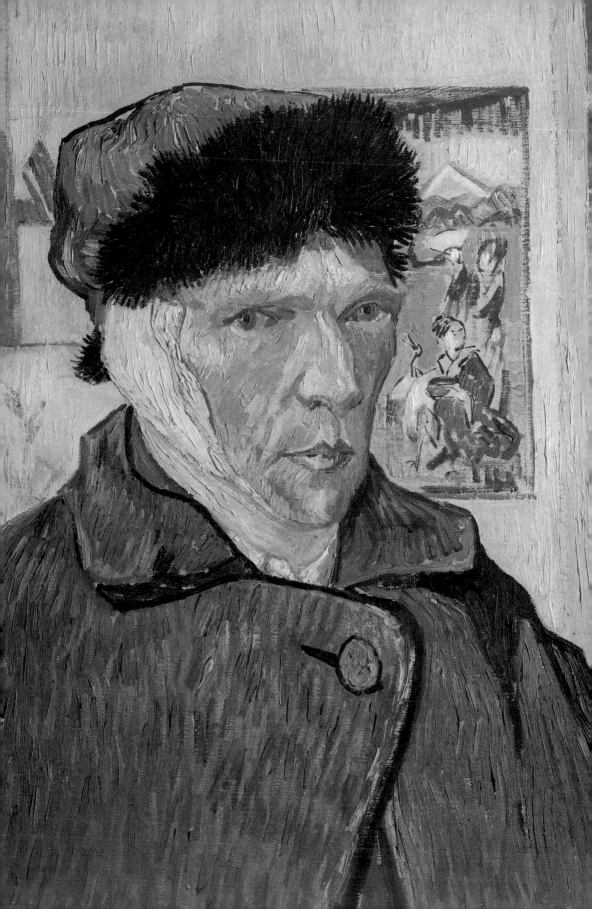

Alfred Nemeczek

Van Gogh in Arles

Prestel

Munich · New York

© Prestel-Verlag, Munich and New York, 1995
© of all quotations from *The Complete Letters of Vincent van Gogh*
(London, 1978) by Thames and Hudson International Ltd.,
London and Bulfinch Press, Boston, MA

Front cover: *Self-Portrait with Bandaged Ear*, 1889 (detail; see frontispiece)
Back cover: *Self-Portrait with Easel*, 1887 – 88
Frontispiece: *Self-Portrait with Bandaged Ear*, 1889

Translated from the German by Fiona Elliott

The publishers would like to thank Elizabeth Clegg for
her assistance in the production of this volume.

Prestel-Verlag
Mandlstrasse 26, D-80802 Munich, Germany
Tel. (89) 38 17 09-0; Fax (89) 38 17 09-35
and 16 West 22nd Street, New York, NY 10010, USA
Tel. (212) 6 27-81 99; Fax (212) 6 27-98 66

Prestel books are available worldwide.
Please contact your nearest bookseller or
write to either of the above addresses
for information concerning your local distributor.

Lithography by eurochrom, Villorba, Italy
Typeset by Reinhard Amann, Aichstetten
Printed and bound by Passavia Druckerei GmbH, Passau
Typeset in Caslon Book

Printed in Germany

ISBN 3-7913-1484-x (English edition)
ISBN 3-7913-1479-3 (German edition)

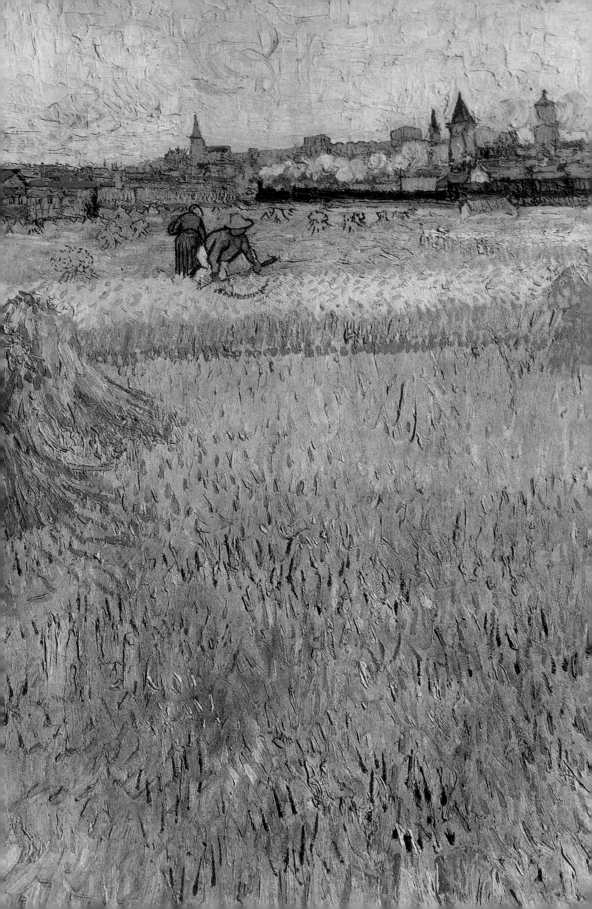

A Filthy Town

"I am often terribly melancholy, irritable…"

The South gave him a frosty reception. Getting out in Arles on the morning of February 20 after a 15-hour train journey, the Dutchman Vincent van Gogh then had to manhandle his luggage through deep snow to the Hotel Carrel in the rue Cavalerie, which he did not even like because it was going to cost him five francs per night. In the coldest February that the town on the Rhône delta had seen since 1860, a good two weeks passed before the painter—having traveled all the way from Paris—was able to find "comfort or warmth" to work in, because "down here it is freezing hard." In the restaurants he could not find potatoes, rice, or macaroni, nor could he find "really strong soup." In a grocer's shop and in a book shop which sold paint, he asked in vain for "some good blue, etc.," and time and again was given the "wrong information about the amount of stamps" at the post office. "You have no idea of the slackness and the nonchalance of the people here," he wrote to his friend the painter Emile Bernard (1868-1941). As far as he was concerned, the contents of the local Musée Réattu were a "horror"; on the other hand, he did say the treasures of the Museum of Antiquities in the former Church of St. Anne were "genuine." And at least in the early days, he agreed with the many guidebooks praising the legendary beauty of the Arlésiennes: "The women here are beautiful, no humbug about that," as he noted down at the end of February 1888. At the beginning of May, he revised his opinion: "They are, no question about it, really charming, but no longer what they must have been…for they are in their decadence." And Arles itself: "It is a filthy town this, with the old streets."

Could the inhospitable weather during those first weeks have been the reason why the lone Dutchman, in a city of 23,000, had such difficulty acclimatizing to his new home? Or was it because Arles—founded by the Greeks in the sixth century B.C. and becoming famous around 30 B.C. under the Emperor Augustus as the Rome of Gaul—had lost much of its importance during the second

Wheatfield with View of Arles, 1888

Overleaf:
Orchard in Bloom with Poplars in the Foreground, 1889

7

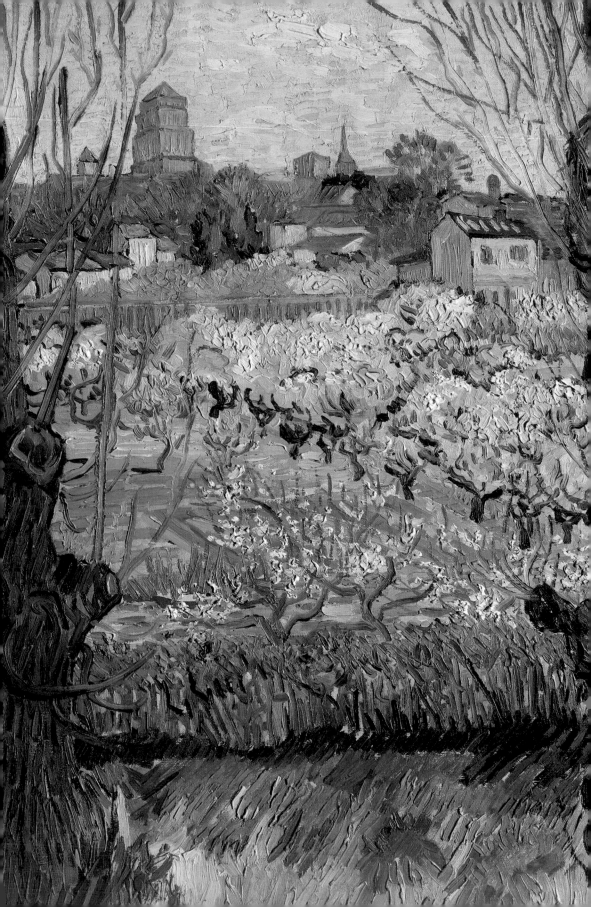

half of the nineteenth century, and had taken on a very different character? The town no longer drew its character solely from what was left of its ancient past, the days of the Roman occupation, and the Middle Ages, which had left the huge arena and St. Trophime's Cathedral with its magnificent eleventh-century West Wall: now there were also the chimneys from the gasworks, the new bridge over the Rhône between the Old Town and the new suburb of Trinquetaille, and, most significantly, the railway. Roundabout 1848 a large part of the ancient Les Alyscamps cemetery had even been sacrificed by the town planners to this new form of transport, which was absolutely vital to the industrial future of Arles as a community in Provence. Or could Van Gogh's discomfort simply have had its roots in his own character and in the very nature of his existence which always just seemed to invite trouble?

Even as a boy he had been bothered by what he called "the blues," which his father, Pastor Theodorus van Gogh (1822-1907), bemoaned, taking them for a lack of *joie de vivre* in his first son (born on March 30, 1853). Later on Vincent referred to his oversensitivity "physically as well as morally" and listed the symptoms: "I am often terribly melancholy, irritable, hungering and thirsting, as it were, for sympathy; and when I do not get it, I try to act indifferently, speak sharply, and often even pour oil on the fire. I do not like to be in company, and often find it painful and difficult to mingle with people, to speak with them."

His outward appearance was described by most of his colleagues as coarse, ugly, and uncouth. In the words of the painter Archibald Standish Hartrick in 1886, this "scrawny little man… with haggard features, red hair and beard and light blue eyes" was so distressed by his appearance that sometimes in his self-portraits and letters he would exaggerate it, in fact creating something rather larger than life. As he wrote from Arles to his sister Wil: "The more ugly, old, vicious, ill, poor I get, the more I want to take my revenge by producing a brilliant color, well arranged, resplendent." It is as odd as it is revealing that in his adulthood he never allowed himself to be photographed. This then led in 1980 to an experiment carried out by the magazine *ART*. The Viennese illustrator Gottfried Helnwein accepted a commission to construct a color "photograph" of the artist on the basis of his self-portraits, using tempera and the finest possible paintbrush (see illus. p. 121).

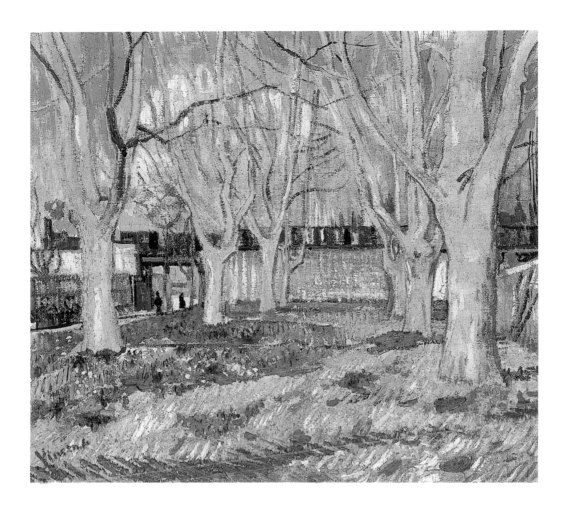

Lane with Plane Trees,
1888

Vincent van Gogh came to Arles as an eccentric, but worse still than that, this outsider was also a failure, now on his fifth attempt to find out what he should be doing with his life. As he tried to convince himself in 1880, "I am good for something, my life had a purpose after all, I know that I could be a quite different man: How can I be useful, of what service can I be? There is something inside of me, what can I be?" He had tried his luck in five bourgeois careers, but all these endeavors were doomed to failure–although by no means through a lack of intelligence, diligence, or commitment on his part.

In 1869, like others in his family before him, he went as an apprentice dealer to the art dealers Goupil & Cie. in The Hague. Two of his father's brothers were already with this international com-

pany. He then moved on to the firm's branches in London and Paris, but an unhappy encounter with love and the unexpected blessing of pietist belief presented him with a choice: should he be selling pictures or serving the Lord? He left the art dealers Goupil & Cie. and became a private tutor and lay preacher in England. But he only managed to do this from April to December 1876 because he was seldom paid a single penny for his work. So one of his uncles, also by the name of Vincent, found a position for this astonishingly well-read young man in the Dordrecht book shop Blussé & Van Braam. But his stay there was of equally short duration, for Vincent van Gogh, now 24 years old, still yearned to become a "sower of God's words."

Yet again his family was there for him as a safety net and provided him with the financial means to set out on careers number four and five, but yet again he slipped helplessly through their grasp– beyond their reach this time. Full of confidence, Van Gogh had embarked on a seven year project which offered him the chance to become a pastor one day. Before studying theology, however, he had to complete his final school examinations in Amsterdam because after primary school he had only attended middle school for a year and a half. But after a mere fourteen months' private tuition in Amsterdam, the candidate gave up his studies, having come to the conclusion that "the whole university" was "an inexpressible mess, a breeding place of Pharisaism." This "worst time I have ever lived through" was to be followed by even worse still, with Vincent van Gogh soon suffering further failure, this time in 1879 in the Belgian mining area of Borinage, where he was training as a lay preacher under the auspices of a School of Evangelists in Brussels. In Borinage he gave of his ability to help and empathize with others to the point of self-sacrifice–caring for the sick, lending spiritual support to others, a brother to all those in need. He would give away clothing and money, travel into the mines with the exploited workers and (as one priest observed), if he saw a snail would even "pick it up and put it on a tree" just like the Franciscans. Despite all this he did not pass his probation, with the School's directors in Brussels declaring that he was without the "gift of language."

In that summer of 1879 Vincent van Gogh lost more than just a job, for now he was becoming increasingly aware of the fact that he had, in all likelihood, forever spoiled any chance of financial inde-

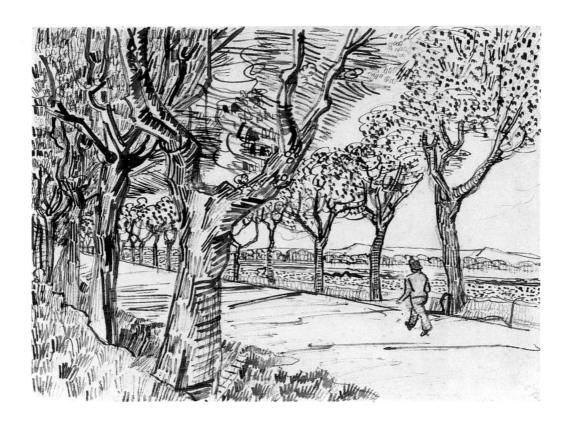

pendence or of realizing his own plans. It is true he did try through-
out his life to fend off the notion of himself as a born loser and was
forever devising new ways of earning a living. But after his dismissal
in Belgium, which had also effectively cured him of his fundamental-
ist piety, Vincent became ever more certain that all his future efforts
to achieve any kind of security would hinge on someone very close
to him who had already shown a better grasp of life than himself,
namely, his younger brother Theo, who had also trained as an art
dealer.

It was to Theo that Vincent was to send most of his 796 pub-
lished letters which have made it possible for subsequent generations
virtually to relive step by step the birth of modern art, his individual
case serving to typify the whole movement. Vincent wrote his first
letters to Theo in 1872–73, when he was an apprentice in The
Hague and Theo had just started in the Brussels branch of Goupil

& Cie. And Vincent had the draft of his last letter to him in his jacket pocket on July 27, 1890 in Auvers-sur-Oise when he fatally injured himself with a pistol. Theo had visited Vincent when he was studying in Amsterdam, and then again in Borinage in Belgium, somewhat alleviating his poverty with small sums of money. Vincent was still financially dependent on his parents, so Theo, who had been transferred to Paris in 1878 and was now earning reasonably well in the art dealer's, helped out. And then one day their father died. Vincent had fallen out with the family and Theo now took full responsibility for his brother. It was what Vincent had been hoping for, as he wrote to Theo from Belgium: "If I have come down in the world, you, on the contrary, have risen. If I have lost the sympathy of some, you, on the contrary, have gained it. That makes me very happy—I say it in all sincerity—and always will. If you hadn't much seriousness or depth, I would fear that it would not last; but as I think you are very serious and of great depth, I believe that it will. But I should be very glad if it were possible for you to see me as something more than an idle man of the worst type."

It would have been unthinkable for Theo to let down such warmth of feeling, such brotherly trust, particularly in view of the fact that from autumn 1880 onwards Vincent was by no means a good-for-nothing. On the contrary, he was making one last, superhuman effort to alter the course of his fate and to find the answer to the question: "What can I be?"

Vincent van Gogh had decided to become a painter—a career that he was well prepared for and which he approached with greater seriousness than anyone else has ever done. As a child he had drawn quite well, but as a young man what he had done "did not amount to much" and later on he resisted "making rough sketches," however much he sometimes wanted to. For in his words during his training as a missionary: "as it would probably keep me from my real work, it is better not to start." He already had a wide knowledge of painting from his time at the art dealers', and on his many gallery visits had become closely acquainted with the works of the Old Masters. At the same time, he steadily collected reproductions of paintings by artists from the then highly influential open-air schools in Barbizon and The Hague. He had barely arrived in London in 1873 when he was already enthusing about the "clever painters" there, and immediately listed nine names—from Sir John Everett Millais (1829-96)

View of The Hague with the Nieuwe Kerk, 1882-83

and George Henry Broughton (1833-1905) to James Tissot (1836-1902). Six months later his list of "painters I particularly love" had already increased to 54 and was followed with the comment: "But I might go on like that for I don't know how long. Then there are the old masters, and I am sure I have forgotten some of the modern ones." All around him in everyday life he sought out "what was suitable for painting," and when he discovered Shakespeare he responded as the artist he was: "His language and style can indeed be compared to an artist's brush, quivering with fever and emotion."

He himself did not touch paintbrush and oils until two years after starting his autodidactic art training. But in Borinage, where he was fascinated by "types from here," he could not resist the impulse to draw: "Often I draw far into the night, to keep some souvenir and to strengthen the thoughts raised involuntarily by the aspect of things here." Soon he became more systematic. In addition to lithographs, etchings and photographs of works by artists past and present, he also acquired Charles Bargue's professional *Drawing Course*. He

15

made copies from these sources over and over again. He hoped, writing reassuringly about it to Theo, "to learn to make some drawings that are presentable and salable as soon as possible, so that I can begin to earn something directly through my work."

With greater patience and understanding than any other beginner, he approached practical art without any illusions. He was highly suspicious of "those who neglect solid study in the beginning, and who hurry and hasten to get to the top." Moreover, he was well aware that "there are laws of proportion, of light and shadow, of perspective, which one *must know* in order to be able to draw well; without that knowledge, it always remains a fruitless struggle, and one never creates anything." Uncompromisingly he rejected "certain prejudices…particularly the idea that painting is inborn." In his view, endurance was much more important: "If one wants to become a painter, if one delights in it…one can do it; but it is accompanied by troubles, cares, disappointments, times of melancholy, of helplessness." As his experience grew, he cursed drawing as being like "working through an invisible iron wall that seems to stand between what one *feels* and what one *can do*." But now that he had a clear aim, he felt better than he had done for a long time: "though I feel my weakness and my painful dependence in many things, I have recovered my mental balance, and day by day my energy increases."

Moments of happiness in reward for effort, worry, disappointment, depression, weakness, dependence and helplessness–this was to be the pattern of his life from now on, and it is reflected in his correspondence. He hardly sold anything in the places he moved to next–Brussels, Etten, The Hague, Drente and Nuenen–nor did he find any "regular work as a draftsman," where he had hoped he would at least "be able to count in some way on 100 francs a month." Poverty was compounded by unhappy love, and trouble with his relatives was exacerbated by illness. Yet he trustingly reported even the smallest artistic progress: "But it seldom happens that a figure is a total failure, I think the expense of the models will pretty soon be repaid." And: "It is the painting that makes me so happy these days."

The fact was that he owed Theo news like this of success, owing it to himself even more. For his brother, such news served as the ideal cover for his continuous (albeit sometimes rather slow) support. For the painter, news of success was essential to keep his fragile self-confidence on an even keel. As the Mannheim art historian Ro-

land Dorn has shown,[1] these small successes apparently allowed him to feel that "his own thoughts and deeds were the result of serious intellectual reflection and reasoning." At the same time, Dorn questions the quality of this process of reflection and shows this letter-writer to be "conceptually imprecise," giving rise to "a good deal of undisciplined thought." From this Dorn draws the conclusion that "avoiding any very rigorous intellectual hold on the seemingly obvious had some dubious advantages: it allowed the artist to generalize his own personal experiences and to hide his own personal needs behind perfectly good reasons without having to face up to the now irrational, now sentimental, now idealistically utopian core of his thinking."[2]

Had Vincent van Gogh himself been confronted with this illuminating analysis, he would presumably never have touched a paintbrush again. Sensitive as he was to even the mildest criticism, it was in fact his own critical self-reflection and the constant pursuit of new perspectives on life, new strategies, even castles in the air and utopias which for years kept insanity and thoughts of suicide at bay, however much he did hint at them. In addition to this, his letters were invaluable as a written check on his artistic production. Particularly

Carpenter's Yard and Laundry, 1882

when he was in Arles, he would justify to Theo (and thus also to himself) almost every motif that he painted.

"Must I tell the truth," he wrote on March 18, 1888 to Theo, "and add that the Zouaves,[3] the brothels, the adorable little Arlésiennes going to their first Communion, the priest in his robes, who looks like a dangerous rhinoceros, the people drinking absinthe, all seem to be creatures from another world?" These words, further evidence of Van Gogh's lack of interest in the daily life of Arles, can probably only be properly understood with a knowledge of his plans for himself in the town on the Rhône, make or break plans to which he was utterly committed – intellectually undisciplined or not.

Bold Ideas

"I firmly believe in the possibility of an immense renaissance of art."

Excitement and impatience consumed the artist as he looked out of the carriage window on the way to Arles. In Vincent van Gogh's own words: "How I peered out to see whether it was like Japan yet." No, his brother Theo had not put him on to the wrong train at the Gare du Midi, and the traveler was not in a state of mental confusion, although on his journey he was "very miserable, almost an invalid and almost a drunkard." In Paris, on the previous station of his Odyssey as *peintre maudit*, he became so "seriously sick at heart and in body" that he had to go "off somewhere down south, to get away from the sight of so many painters that disgust me as men."

The "child's game" of calling Provence Japan was not just a game, but had rather more to do with his development as a painter

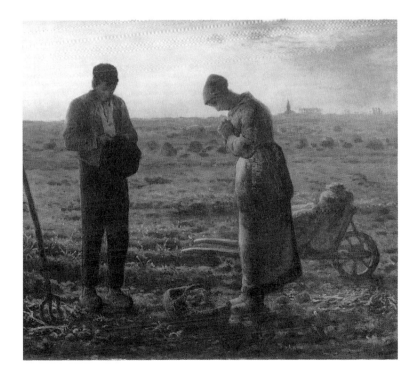

Jean-François Millet,
Angelus, 1854-59

and the immense progress he had made since the days in Nuenen, where he had successfully completed his first major programmatic work *The Potato Eaters*. At that time, he had decided on Jean-François Millet (1814-75), "the great master," as his guiding star. In Vincent's letters there are over 200 references to the farmer's son whose early realistic paintings of social revolution later gave way to sentimental scenes of rural working life. Twenty-five of Van Gogh's pictures are copies of Millet's work, including the famous country-side idyll *Angelus* (illus. p. 19). In Alfred Sensier's idealizing biography of Millet (1881), Vincent discovered parallels to his own life: "Millet and others before us have held out right until the bailiffs." Second place as master went to the Romantic Eugène Delacroix (1798-1863), who is referred to a good eighty times in the letters, including that memorable phrase—dreamt up from who knows where—"When Delacroix paints, it is like a lion devouring a piece [of meat]." He learned about Delacroix's color theories from a book by Charles Blanc and compared them "in their connection and completeness for general use" with Isaac Newton's work on gravity and with George Stephenson's steam engine: "that those laws of colors are a way of light—is absolutely certain."

Taking a lead from Millet, Van Gogh was concerned throughout his life never to lose sight of the social responsibility of art, the human element in painting. And he was impressed that Delacroix "absolutely dominates his colors." The third pillar of his homemade theory of aesthetics was a phenomenon which at first sight would hardly seem to match the other two guiding stars, for it was "Japonaiserie" which he had become acquainted with through the writings of the brothers Edmond and Jules de Goncourt. As he wrote to Theo in 1866 from Antwerp, where he attended a foundation course at the Art Academy for a short while: "I have pinned a lot of little Japanese prints on to the wall, which amuse me very much. You know those little women's figures in gardens, or on the beach, horsemen, flowers, knotty thorn branches." A few months later in Paris the painter would become passionately interested in collecting these *ukiyo-e* prints (*ukiyo-e* being the Japanese for floating world). This passion had a major impact on his own work as an artist and visibly changed his approach. Now, in the backgrounds of his *Portrait of Yves Tanguy* (the paint dealer; illus. p. 25) and of his *Portrait of Agostina Segatori*, he alluded to these prints with their clear contours and

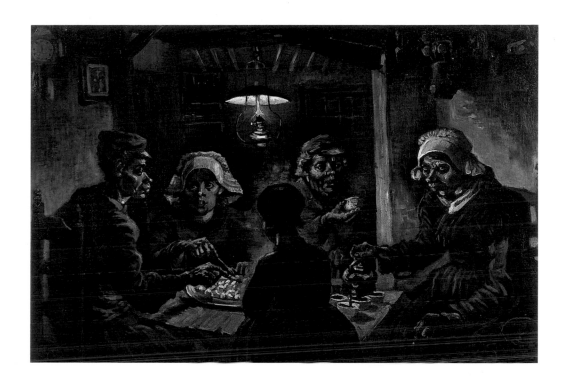

The Potato Eaters, 1885

strong colors, which were viewed as no more than trivial in Japan. In his oil paintings he drew on the shadowless themes of Utagawa Hiroshige and Kesai Eisen, and gave his *Portrait of Woman with Carnations (La Segatori?)*, (December 1887; illus. p. 26), a distinctly Oriental feel. "My whole work," he later wrote, "builds so to speak on what the Japanese have done." Japan, this "metaphor for the longing for a place where art was perfect"[4] had given form to Van Gogh's vague notion to go south. The Hamburg art historian Uwe M. Schneede sees the artist as always intent on having a reason for what he was doing: "[he] surrounded his life in Provence with a kind of pretense, in order to legitimize the Utopian aspect of what he was doing."[5]

At first all he had wanted to do was to regain a sense of "tranquillity and poise," to "take it easy": "And in the meantime I should spend my time drawing every day, with two or three pictures a month besides." In his own words again: "…you know that I came to the South and threw myself into my work for a thousand reasons.

Wishing to see a different light, thinking that looking at nature under a bright sky might give us a better idea of the Japanese way of feeling and drawing. Wishing also to see this stronger sun, because one feels that one could not understand Delacroix's pictures from the point of view of execution and technique without knowing it, and because one feels that the colors of the prism are veiled in the mist of the North."

It may not have been a thousand, but the traveler to Japan certainly had more thoughts than these alone on his journey to Arles, a place where no artist is known to have settled before him. Little by little he set out bold plans in his letters for a detailed strategy for reforming the art market and for a much needed revitalization of the art of his day. The motivation for this had been the experience of his two years in Paris, during which time the autodidact had radically changed his style and come up against the reality of the art market for the first time.

At the start of those two years Theo, himself 29 years old at the time, had taken into his bachelor flat a traditionalist who was more interested in the basics of the craft than with questions of style. His knowledge of developments in contemporary art was confined to the open-air schools of Barbizon and The Hague–Anton Mauve, a member of the latter and a distant cousin had occasionally given him advice at the outset of his self-directed studies. This then explains his enthusiasm when he was first in Paris for the radiance of Adolphe Monticelli's flower paintings with their thickly applied oil paint. Monticelli (1824-86) had died not long before in Marseilles, and Van Gogh now painted 30 powerful flower pictures and elevated this not particularly modern contemporary into his Pantheon of house-gods alongside Millet and Delacroix. Although Theo was in the trade himself, he had not enlightened his brother about the state of the debate surrounding the notion of the revitalization of art. "There is a school–I believe–of impressionists," Vincent wrote uncertainly as late as 1885, "but I know very little about it." By his second year in Paris at the latest, he himself was really a kind of Impressionist and had his own views on Symbolism and Pointillism, emerging then or a little later. He pursued his studies in the private studio of the influential salon artist Fernand Cormon (1845-1924), and during a short period of only three months as a guest there found well-informed friends amongst his generally younger colleagues. They resisted the

Japonaiserie: The Courtesan (after Kesaï Eisen), 1887

Detail of illustration on p. 25

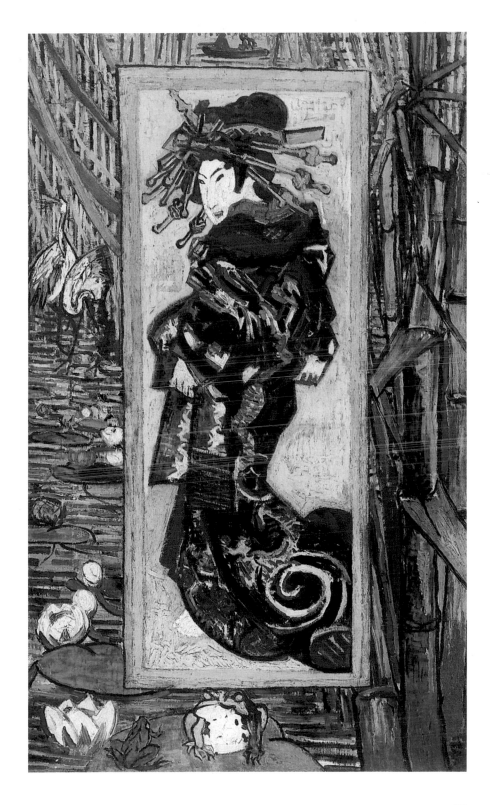

still dominant allegorical-anecdotal salon painting by such pretentious artists as Jean-Léon Gérôme (1824-1904), Thomas Couture (1815-79), or Adolphe William Bouguereau (1825-1905). They even kept warily away from the discoverers of Impressionism. During this time Vincent painted in the Parisian suburb of Asnières together with the Pointillist Paul Signac (1863-1935) and the future Symbolist Emile Bernard, who later introduced him to Paul Gauguin (1848-1903), himself an outsider. He also sat for portraits by the Australian John P. Russell and the painter, drawer, and lithographer Henri de Toulouse-Lautrec (1864-1901), who took him to Aristide Bruant's Cabaret Le Mirliton in December 1886.

The works by Vincent's friends had as little success in the art market as his own. Even the most talented faced destitution. The painter Camille Pissarro (1830-1903), a founder of Impressionism, was one such. Ten years later, by 1886, he had established himself and achieved recognition, but, despite his contacts with three galleries, in 1887 he earned less than 4,000 francs with his work. Small wonder that his wife Julie lost heart: "I have no money and nobody will give me credit…What are we to do? We are eight at home to be fed every day."[6] Other Impressionists, most notably Claude Monet (1840-1926), who could command up to 2000 francs for one picture, profited from a bold move by the Parisian gallery owner Paul Durand-Ruel to extricate himself from financial embarrassment. In March 1886 he shipped roundabout 300 modern paintings to New York and was rewarded for his exhibition and sale there with at the very least a *succès d'estime*, as the art historian John Rewald reported.[7]

The situation was as Vincent described it in a letter to his English artist friend Horace Mann Livens: "The great dealers sell Millet, Delacroix, Corot, Daubigny, Dupré, a few other masters at exorbitant prices. They do little or nothing for young artists." They were relegated to second class galleries like the art shop owned by Julien ("Père") Tanguy, who would sell Van Gogh's pictures for a mere 20 francs, or galleries like the Independents' Salon, a non-selective exhibition first put on in 1884 for artists who would not stand a chance of being accepted by the selectors of the official Salons. At the end of March 1888, Theo had three of his brother's pictures shown there.

Shoulder to shoulder with Theo, by now an experienced dealer, Vincent van Gogh wanted to do something about this unhappy state

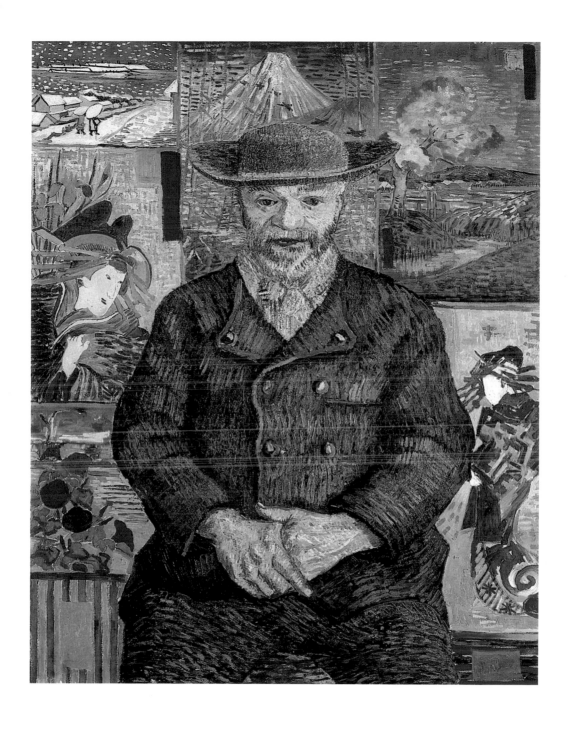

Portrait of Père Tanguy, 1887

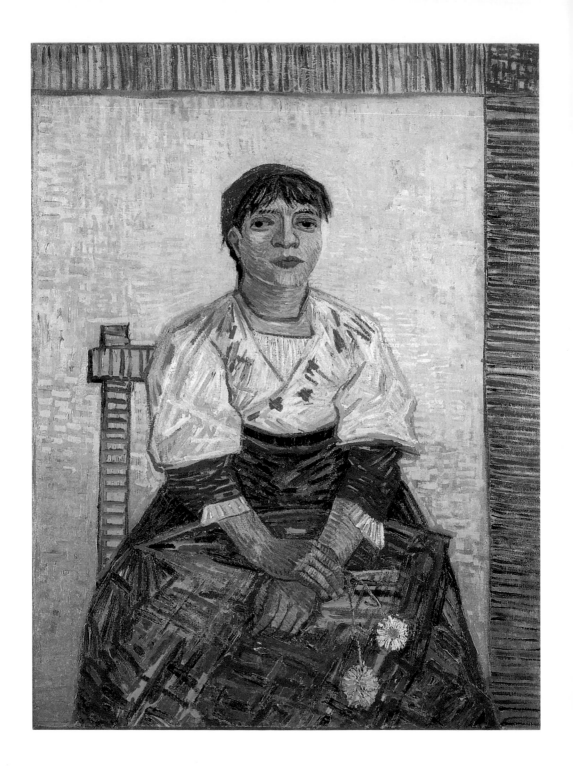

Portrait of Woman with Carnations (La Segatori?), 1887-88

of affairs, and he brought with him to Arles something of a mandate for this. For in his hectic months in Paris – "I was certainly going the right way for a stroke" – he had discussed the situation in the art market in various studios and had himself even organized two exhibitions. Colleagues in the art world were happy to accept his lead in these matters. In the Restaurant du Chalet on the avenue de Clichy he put on the exhibition with about 100 of his own works as well as works by other Impressionists: for simplicity's sake using this term for all artists who were not part of the artistic establishment: Bernard, Toulouse-Lautrec, Louis Anquetin, Arnold Hendrik Kooning, and probably also Armand Guillaumin. A month later Van Gogh made a guest appearance along with his friends' works in the rehearsal rooms of the Théâtre Libre on the rue Blanche.

His first move in icy Arles was therefore to hatch plans for an invasion of England and the Netherlands using the conventional weapons of the art world: works from Paris were to be infiltrated into London by one of Theo's middlemen, or even by Theo himself. There they were to be exhibited and offered for sale. The Hague was to be taken with the help of Theo's employers, now a branch of the art dealers Boussod, Valadon & Co (formerly Goupil & Cie.[8]). At the end of February, Vincent composed a letter for Theo to his colleague, Hermanus Gijsbertus Tersteeg, inviting him to visit the Paris studios and pointing out how reasonably priced the paintings were. Tersteeg would certainly be able to handle "a good fifty" of these pictures in Holland. Vincent was confident: "besides, he *will be obliged* to have some of them, because if they are already being talked about in Antwerp and Brussels, they will likewise be talked about in Amsterdam and The Hague before long." As a flanking manœuvre on the publicity front, Vincent's "plan of attack" included presents of paintings to prominent figures in Dutch society. He himself was going to see about "a permanent exhibition of the Impressionists" in nearby Marseilles. The brothers had to admit defeat, despite some initial success. Tersteeg did admittedly accept a small, representative consignment of Impressionist paintings, but sent them all back unsold after eight weeks.

The second scheme thought out by Vincent – a generous, forward-looking attempt to unite art and commerce, artists' lives and what he so often cursed as "real life" – ended shortly before Christmas in a widely recounted catastrophe. The artist could not have

suspected anything of this sort when he wrote in the middle of March to his brother, showing himself as the pragmatist he was. After a few introductory remarks ("What do you think of the news of Kaiser Wilhelm's death?"), he sketched out the plan for the foundation of a society: established, but above all less well-kown Impressionist artists should band together, pool their works and share the profits of any sales "so that the society could at least guarantee its members a chance to live and work." Prominent artists such as Edgar Degas, Claude Monet, Auguste Renoir, Alfred Sisley or Camille Pissarro were, according to the plan, to submit works to the value of 10,000 francs and to invite younger artists such as Armand Guillaumin, Georges Seurat or Paul Gauguin to make up the stock of this producer's gallery, although it was not yet called this. In Vincent's opinion, the advantages of this scheme were that "the great Impressionists…while giving pictures which would become general property, would keep their prestige, and the others could no longer reproach them with keeping to themselves the advantages of a reputation no doubt acquired primarily through their personal efforts and individual genius, but all the same a reputation that is growing, buttressed and actually maintained by the pictures of a whole battalion of artists who have been working in continual beggary up to now." He had even thought about an artist's rights after the initial sale, a problem that is still with us today. This can be seen in a later letter to Paul Gauguin. Vincent wanted to secure for his colleagues "their share in the price which, under the present circumstances, pictures only bring a long time after they leave the artists' possession." Nothing is known of the artists' reactions to this suggestion of a long-term contract, only of Vincent's first, somewhat modified move in this direction.

Only four days later in a letter to Theo he expressed the wish "for many reasons" that he could found "some sort of little retreat, where the poor cab horses of Paris, that is, you and several of our friends, the poor Impressionists, could go out to pasture." On May 1, Theo's 31st birthday, he rented four rooms for 15 francs a month in a building painted bright yellow in the place Lamartine. And this Yellow House was gradually to become more than a studio and somewhere to live for the tenant: Vincent van Gogh saw it as the "beginning of an association" of artists, as the first seed of "a new art of color, of design, and of the artistic life." His encounter with "officially recog-

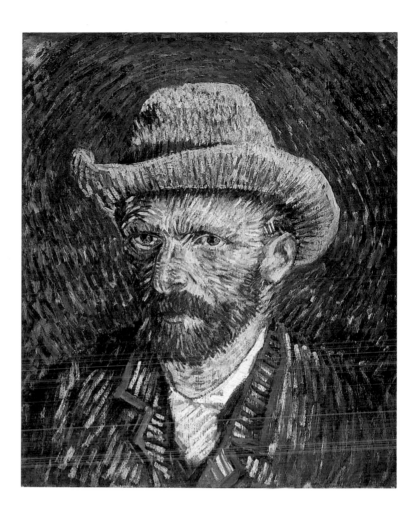

Self-Portrait with Gray Felt Hat, 1887-88

nized art" in Paris had been painful. He saw "its training, its management, its organization" as "stagnant-minded and moldering, like the religion we see crashing, and will not last." A "studio for a renaissance and not for a decadence" could be the answer.

The painter, now visionary, believed firmly "in the possibility of an immense renaissance of art" with a future that he located either "in the South" or more radically in "the tropics." He sensed the advent of "a new world" and a demand for artworks which one artist alone could not fulfill: "More and more it seems to me that the pictures which must be made so that painting should be wholly itself, and should raise itself to a height equivalent to the serene summits which the Greek sculptors, the German musicians, the writers of French novels reached, are beyond the power of an isolated indi-

vidual; so they will probably be created by groups of men combining to execute an idea held in common."

Van Gogh knew and feared the "lack of cooperative spirit among the artists, who criticize and persecute each other...," yet, as far as he was concerned, it would be "bad policy to stay here alone, when two or three could help each other to live cheaply." He had in mind "something of the same nature as the Society of the Twelve English Pre-Raphaelites,"[9] and he had long known who its first members might be: his brother Theo would need to cast aside the yoke of ordinary employment and in the "studio and refuge right at the gates of the South" become "one of the first, or the first dealer-apostle" at the same time, however, as having overall charge of funding. From Brittany, where a small painters' colony had established itself in Pont-Aven, they were to be joined in Arles by Charles Laval (1862-94), Henry Moret (1856-1913), and above all Emile Bernard. Vincent used to exchange long letters with this highly talented poet, painter and theoretician. Almost like a father he would advise this friend from his time in Paris (Bernard was just 20 years old), exchanging pictures with him and telling him before anyone else about his notion of group works in the future. Bernard obediently signalled that he would join them, but failed to appear. Vincent made even greater efforts to secure an older colleague, painting at the time in Brittany with Bernard, and who was self-taught like himself: Paul Gauguin, then 40 years old. Of all the painters he knew, he respected the one-time sailor and stockbroker most highly of all, utterly self-effacing in his admiration. He imagined Gauguin as the "abbot" in the Yellow House and wrote to him that he should "from now on... begin to feel like the head of the studio." Gauguin held back initially, although he was, in the end, the only one who in fact did go to Arles. He was utterly bankrupt, and Theo had to pay for his travel, food and lodging and materials.

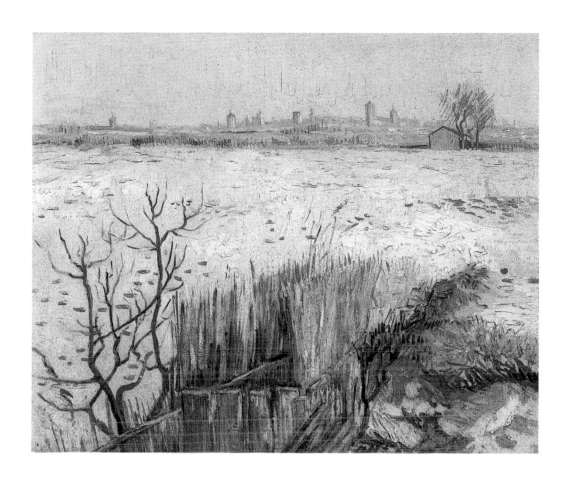

Modern Paintings

"I fasten my easel to pegs"

Landscape with Snow, 1888

As far as his painting was concerned, for the first weeks in Arles Vincent did not need to do anything in particular; the magic word Japan was quite enough. He saw "landscapes in the snow, with the summits white against a sky as luminous as the snow," and he immediately painted the scenes he saw, for they "were just like the winter

31

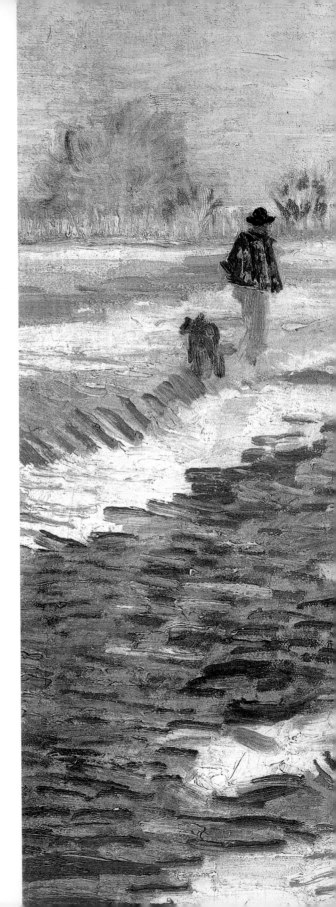

Landscape with Snow, 1888

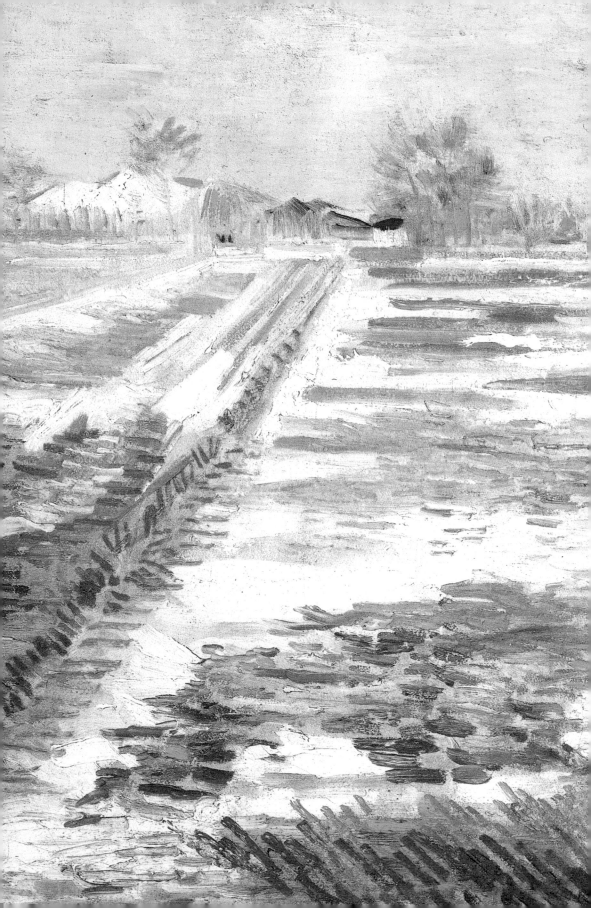

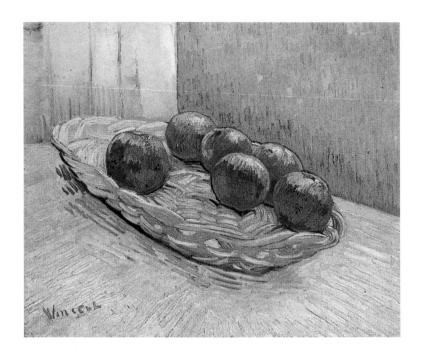

Basket with Oranges, 1888

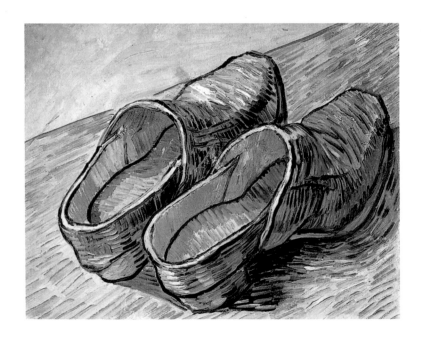

A Pair of Clogs, 1888

34

*Blossoming Almond
Branch in a Glass, 1888*

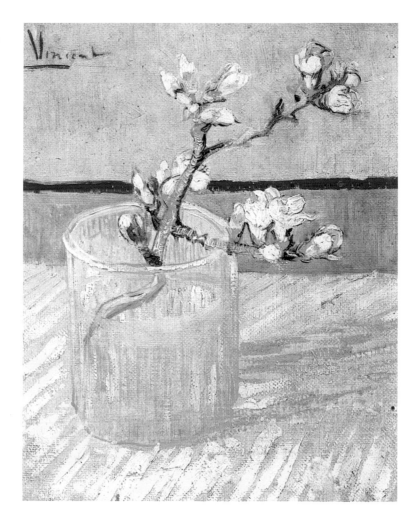

landscapes that the Japanese have painted." And straight away, in the
first of these paintings done only three days after his arrival in Arles,
Van Gogh showed beyond doubt that since his time in Paris he was
completely justified in describing himself as an Impressionist, add-
ing a whole array of colors into the white splendor of a snow-covered
field with the silhouettes of the mountains in the distance. Quite
according to the book, he uses short brushstrokes—dense green di-
agonals in the foreground leading into the depths towards the
horizon in olive green, red, gray, and blue parallels. A man with a dog
serves as the focal point of this simple composition, which has the

added interest against the whitish-blue winter sky of trees like exploding fireworks. There can be no doubt that this was done by one who had suffered so greatly with the bad weather that he had to seize the first opportunity to work again outside. The second (and only other) snowscape (with the town of Arles in the background) shows a far higher degree of artistry and control.

In homage to both Japan and Impressionism, he composed three beautiful still lifes with almond blossom twigs in a glass (see illus. p. 35) and with oranges in a basket. Because of the cold weather he had to work in the Hotel Carrel where he was staying. Two further paintings returned to subject matter he had previously tackled in Holland, but what had once consisted of grays and "browns" now emerged in light complementary colors: a pair of clogs (see illus. p. 34) and a yellow dish with reddish potatoes outlined in black. Two studies in his new surroundings then completed his work at home: a painting

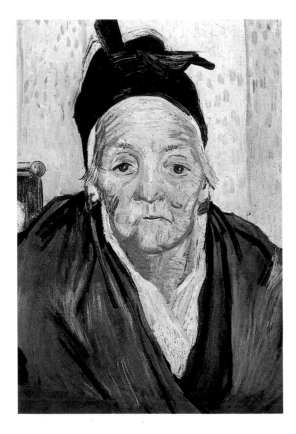

An Old Woman of Arles, 1888

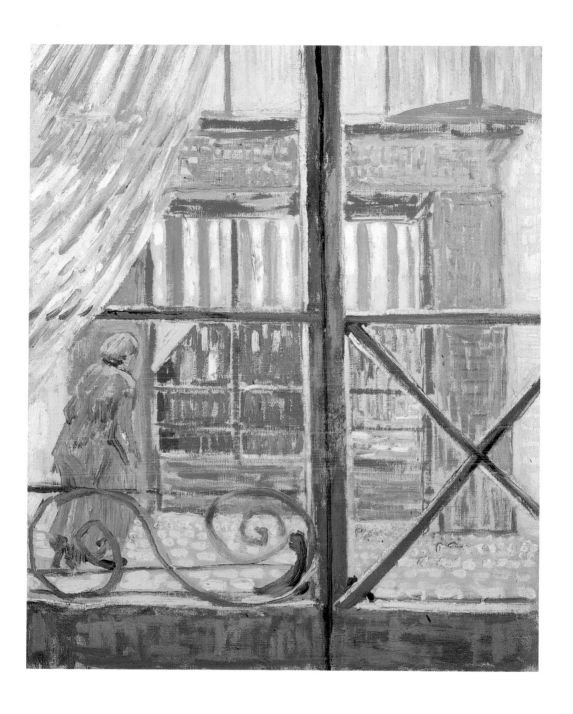

A Pork Butcher's Shop Seen from a Window, 1888

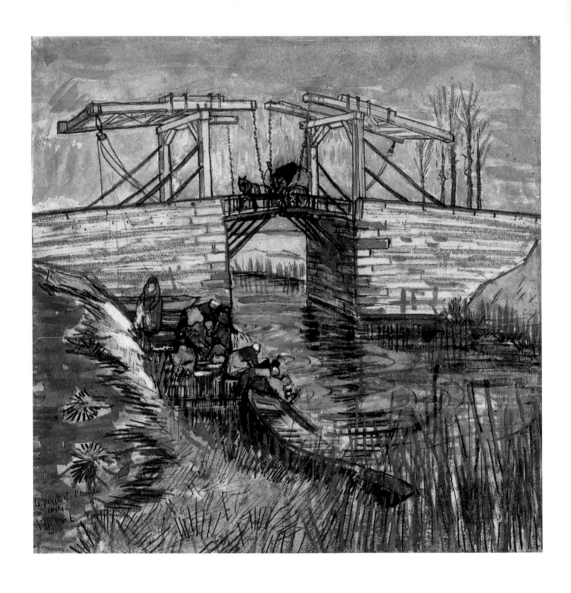

showing the front of a pork butcher's shop seen through a closed window (see illus. p. 37), and the portrait of an old Arlésienne whom he had managed to persuade to sit for him—a simple portrait in which the woman, against a wallpaper, faces forwards out of the picture with Van Gogh allowing himself just a touch of Pointillism in the manner of his Parisian friends Paul Signac and Georges Seurat (see illus. p. 36). "That makes eight studies so far,"[10] he informed Theo after barely two weeks in his new home, and set out to explore

Drawbridge with Carriage (The Pont de Langlois), 1888

his immediate surroundings. The weather had "turned milder – and likewise I have already had an opportunity to learn what a mistral is…it is quite impossible to do anything in this wind."

But only a day later he reports on "two more studies of landscapes," declaring his intention to "set four or five things going" that same week. On a detour to the Arles-Bouc Canal he came across a drawbridge which became his *Drawbridge and Lady with a Parasol* (illus. pp. 40-41). Virtuosic in its composition, with detailed horse and carriage, boat, washerwomen, reeds and six cypresses, it was the first work in Arles which he himself held worthy of the title "picture". After he had drawn and painted it five or six times in situ, he set out to work on a version of this piece of artistic bravura for Theo: "not like what I generally do." The picture "will be better than the study, I think."

Drawing, study, picture. Although Van Gogh by no means always kept to this in practice, and sometimes even described studies as pictures or followed studies with drawings, he nevertheless did hold with this hierarchy. For his work was not only for himself, but for a wider public to which he felt accountable, feeling too that he owed it to that same public to be constantly self-critical, although his public at the outset did admittedly consist solely of his various correspondents. It did, however, matter to him to convince those who were close to him that there was nothing arbitrary about his new, unconventional style, which he himself could even find disconcerting. In this respect, Van Gogh's letters take on a significance which is often overlooked. They served to disseminate understanding of a form of art which had developed in isolation, functioning simultaneously as a vital means of self-discipline for the artist.

In his aim to spread understanding of his work, he imagined how Impressionism might seem to his sister Wil, wasting away in provincial Holland and without any knowledge of contemporary art. "One has heard talk about the Impressionists," he wrote to her from Arles in the spring of 1888, "and when one sees them for the first time, one is bitterly, bitterly disappointed, and thinks them slovenly, ugly, badly painted, badly drawn, bad in color, everything that's miserable… But in *a single day* those twenty [Impressionist painters] whom I mentioned paint… better than many a big noise who has a high reputation in the art world." Always so to speak checking up on himself and rationalizing his activities as purely logical, he filled

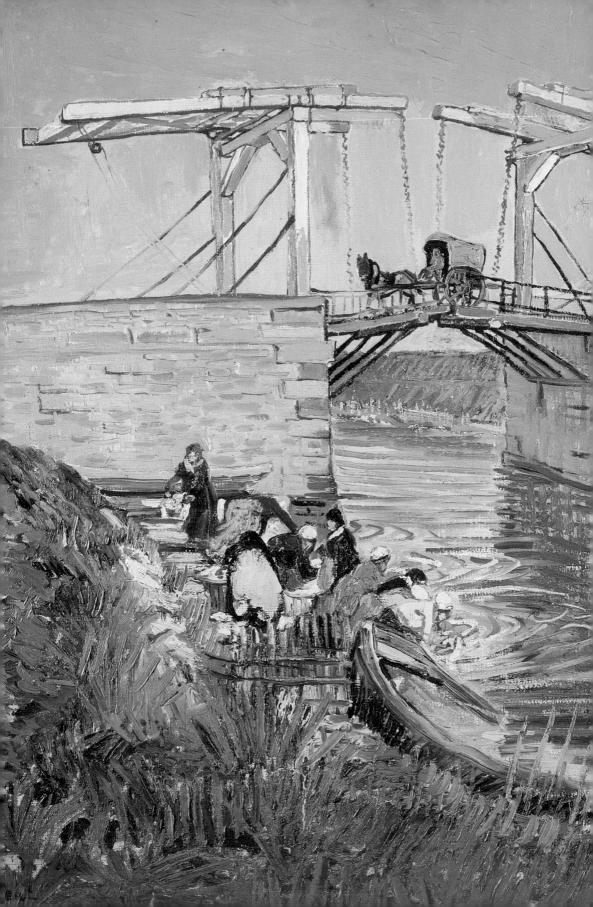

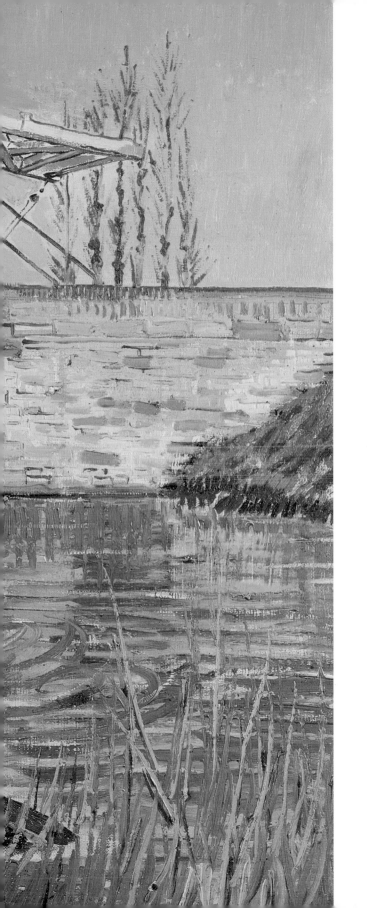

Drawbridge and Lady with a Parasol
(The Pont de Langlois), 1888

41

many pages of correspondence with descriptions of pictures both finished and not yet begun, with analyses of the suitability of what various locations offered in the way of subject matter, with further analyses of color combinations as to their proximity to the color theories of his hero Delacroix, and sought approval for the apparently quite simple, yet very demanding "mental labor of balancing the six essential colors, red–blue–yellow–orange–lilac–green." Van Gogh was anxious that his correspondents should be aware of what he was going through in Arles: "with one's mind strained to the utmost, like an actor on the stage in a difficult part with a hundred things to think of at once in a single half hour."

When winter had been banished by spring, and in Arles the peach, plum, apricot, apple, cherry and pear trees were in blossom, for the first time his earlier comparison seemed to be justified. Van Gogh painted these as though he were on piecework, in his own

Orchard with Apricot Trees in Blossom, 1888

words: "up to my ears in work." Now even the mistral could not hold him back: "I fasten my easel to pegs driven into the ground and work in spite of it, it is too lovely." And since he was "well started now.... There is nothing like striking while the iron is hot," he knew that he would be "all in when the orchards are over."

But at the end of the campaign, after even less than four weeks, he had completed fourteen canvasses. None of the pictures of orchards

Pink Peach Trees, 1888

contain any human figures, and can be seen therefore as "immense still lifes of blossom *en plein air*,"[11] as the art historian Ronald Pickvance called them. Beyond this these works are, however, immensely varied. In some cases paint is applied thinly, in others it is in thick layers; some, for example the *Orchard with Apricot Trees in Blossom* (illus. p. 42), are fully worked out, while others are more like sketches done outside; they are mostly Impressionist in style, although the *Orchard with Cypresses* is largely Pointillist. One work even astonished its creator: "Probably the best landscape I have ever done," was his comment on the *Pink Peach Trees* (illus. p. 43). This was a study completed outside in the open air, which afterwards served as the basis for a strongly colored "picture"–but this later work could not match the intense atmosphere and the tenderness of the much paler original.

In a letter to Emile Bernard he defended the inconsistency of the method used in his *Orchards*: "My brushstroke has no system at all. I hit the canvas with irregular touches of the brush, which I leave as they are. Patches of thinly laid-on color, spots of canvas left uncovered, here and there portions that are left absolutely unfinished, repetitions, savageries; in short, I am inclined to think that the result is so disquieting and irritating as to be a godsend to those people who

have fixed preconceived ideas about technique." A century later Schneede was quite clear that Van Gogh was not merely seeking to provoke: "The aesthetics of such raw pictures was the inevitable consequence and a necessity of his search for the truth of the picture, its method and meaning."[12]

"If there should happen to be a month or a fortnight when you were hard pressed," he wrote to his brother Theo, "let me know and I will set to work on some drawings, which will cost us less." After completing his orchard sequence, he took up this idea at the end of the month and began a "series of pen drawings" of people working in the fields, of meadows in bloom, of vast haystacks, of the public park behind the Yellow House, of a barge on the Rhône and of views of the Crau Plains seen from the ruined Montjamour Monastery outside Arles. The sights of the old town, the cathedral, and the arena were of no interest to him. After a five day trip starting on May 30 to

Fishing Boats on the Beach, 1888

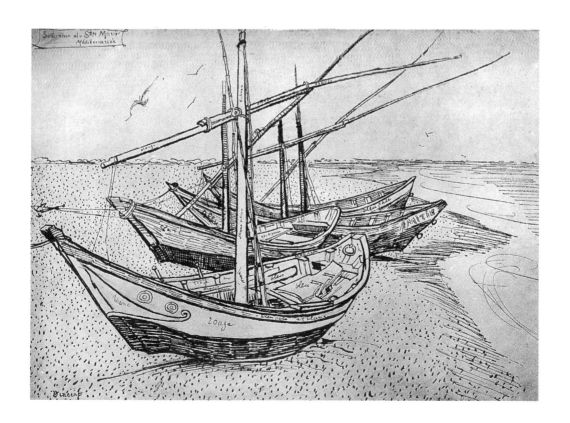

the Mediterranean, Van Gogh returned from Les-Saintes-Maries-de-la-Mer with three studies in oils as well as eight outstanding drawings, including the large-format *Fishing Boat on the Beach* (illus. p. 45). And whether a drawing, as in the case of this seascape, was intended as preparation for work in the studio on a version in oils, or whether it was a piece in its own right, the drawings he made during this time and in the following months secured him a place amongst the best graphic artists in the Western art world. The Dutch researcher Jan Hulsker praises "the precision, control, and drive" with which Vincent could capture "swiftly and unhesitatingly the essence of a landscape."[13] Pickvance is astounded at the variety in Van Gogh's use of the quill (cutting his pens himself): "it can operate like a brush; it can be delicately evocative; it can be brutal and dense yet supremely variable and inventive in its jabs, hatchings and dots."[14] The viewer simply does not notice that these works do not contain color. The ink, at times watery and at others solidly black, enabled the artist to imply an extravagantly rich range of tones. With supreme confidence he incorporated the tones of the paper itself into his compositions, creating tensions between these unworked areas and a clearly inexhaustible repertoire of parallel and cross-hatchings, of circles, whorls and spirals, of garlands, arcades and commas, of passages of dots and musical notation, as well as the ad hoc invention of signs and graphic shorthand which flowed from his quill and steel pens alike. Through his drawings he had long discovered the "new world" that he was dreaming about then.

Yet the artist was not only skilled and inventive in his use of the pen; he also drew at great speed. After his next major series of paintings, the "Summer" and "Harvest" pictures, he completed a good 32 high-quality drawings after his own works for Theo, Emile Bernard, and the Australian painter John Russell (1858-1931)—all within the space of three weeks, during which time he was still continuing to paint as well.

"The Japanese draw quickly, very quickly, just like a lightning flash," Van Gogh concluded, "because their nerves are finer, their feelings simpler." In the next sentence he makes it clear to Theo who he means by "Japanese": "I have only been here a few months, but tell me this—could I, in Paris, have done the drawing of the boats *in an hour*?.... I do it now... just by letting my pen go." But the pace of his work rarely filled him with such innocent pride. On the contrary,

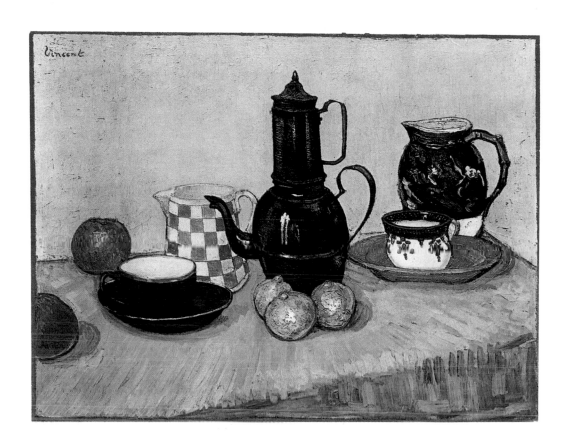

Still Life with Coffee Pot, 1888

he usually felt he had to explain why he worked so wildly with his output growing at such a rate that one might be forgiven for doubting its quality. He attempted to counter Theo's objections before they were raised: "I must warn you that everyone will think that I work too fast. Don't you believe a word of it. Is it not emotion, the sincerity of one's feeling for nature, that draws us, and if the emotions are sometimes so strong that one works without knowing one works, when sometimes the strokes come with a continuity and a coherence like words in a speech or a letter, then one must remember that it has not always been so, and that in time to come there will again be hard days, empty of inspiration."

Van Gogh was wrong here – inspiration never left him, even during his time in the asylum in Saint-Rémy. He was also quite unnecessarily anxious about his supposedly meager output. "I have not yet done half the 50 canvases fit to be shown in public," expressing his

*Harvest
Landscape,
1888*

48

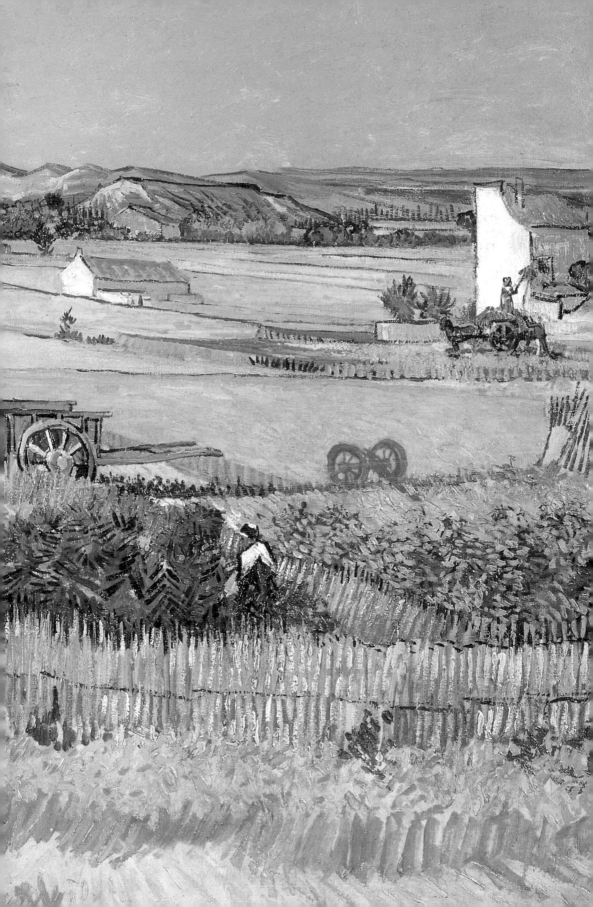

worry in the same letter of (probably) June 16, 1888, in which he had been bemoaning the speed of his work, "and I must do them all this year." He amassed many more than this. In the space of 444 days in Arles, in barely fifteen months that is, a good 200 paintings were completed, almost one every two days, as well as over 100 drawings and watercolours.

When he started work in Arles, he had referred to being "up to my ears in work," and then to a "continual fever of work." But now—summer had come—he was "intoxicated with work" and was letting himself "run to extravagances." And this was the perfectionist who valued carefully considered work above all, who described himself at one point as being "in the midst of a complicated calculation which results in a quick succession of canvases quickly executed but calculated long *beforehand*." He would repeatedly lay one particular picture down on the floor—in order to see it at a distance—which then, lying next to the *Still Life with Coffee Pot* (illus. p. 47) he had painted in May, "absolutely kills the others." This painting was his *Harvest Landscape* (illus. pp. 48-49), a detailed work drawing the eye into the depths of the summer fields on the Crau Plains. And look, even on the floor "with this background of red, *very red* brick, the color of the picture does not become hollow or bleached." The *Harvest Landscape*, in itself evidence of careful planning, was constructed on the basis of two watercolor sketches.

It was, however, quite a different matter when it came to his next piece, which he rated highly, describing it straight away in letters to Theo. This was a painted study (25¼ x 31¾ in.) intended only as the preparation for "a tremendous picture" which was, however, never carried out ("I am almost afraid of it"). In this study Vincent had turned to a theme which had meant much to him since his interest in François Millet: the *Sower with Setting Sun* (illus. pp. 51, 52-53). This canvas was the most radical return for "a week's hard, close work among the cornfields in the full sun," during which time he produced no less than nine studies in oils and one drawing. The *Sower with Setting Sun* stands out amongst these because the painter departed from Nature, conveying the colors of the natural scene in the others—the yellow of the wheat and the sheaves, the red of the wild poppies, the green of the grasses and the blue of the sky. Here only the evening sky is yellow with an ocher cornfield in front of it across the picture like a fence. Approximately two thirds of the

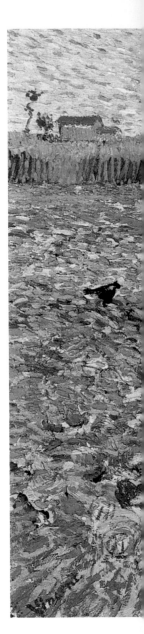

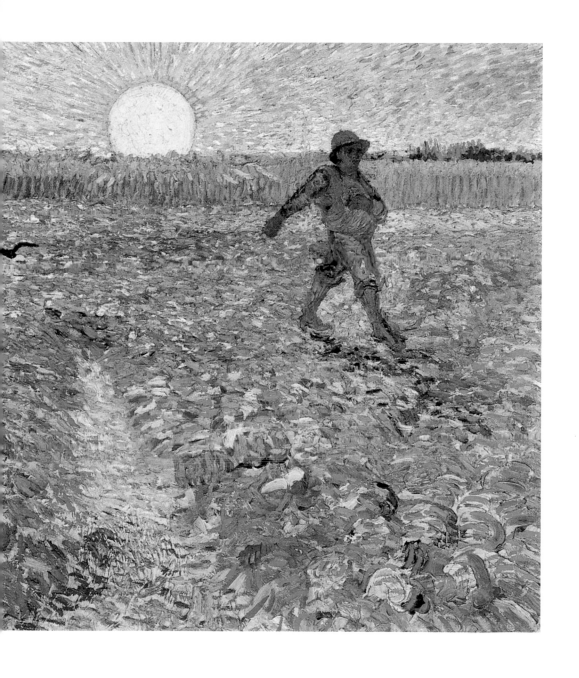

Sower with Setting Sun, 1888

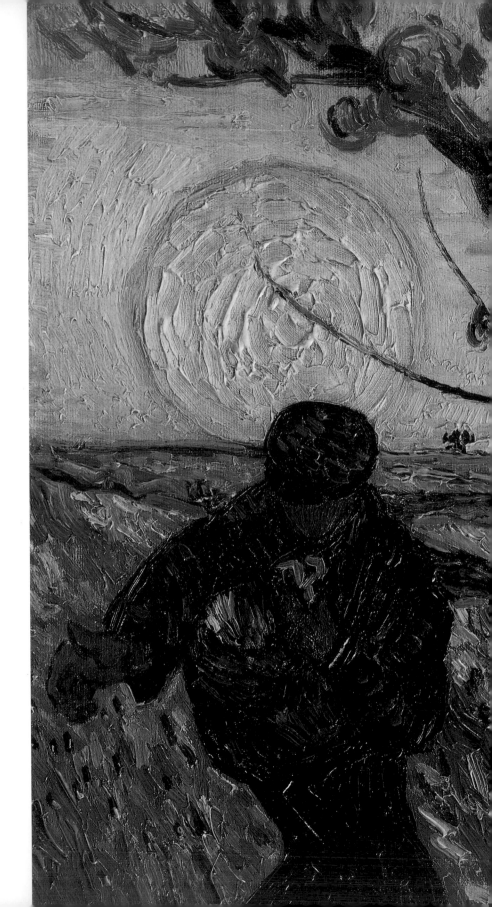

*Sower
with
Setting
Sun,
1888*

52

picture space is taken up by a ploughed field consisting of "clods of violet earth" or, more precisely, of "neutral tones resulting from mixing violet with yellow." "I have played hell somewhat with the truthfulness of the colors," he wrote to Bernard.

With the *Sower*, the sun itself appears for the first time fully in one of his works (an earlier attempt had been unsuccessful), in "chrome yellow No. 1 with a little white.... So very yellow." For the first time the artist was able to show the heavenly body as "a material thing, the most vivid and radiant object of all,"[15] in the words of the art historian Meyer Schapiro. His colleague Horst Keller took this same idea further: "It is a fact: with the exception of Van Gogh no painter has ever painted the sun as it is, as it really appears and as it burns."[16]

The *Sower* is therefore Van Gogh's first large programmatic work in Arles. The *Harvest Landscape* had dealt with a technical-aesthetic problem—above all "the firmness of coloring," even despite all its qualities as an Elysian impression with "'speeded up' perspectives that draw the viewer into the picture" (Jan Bialostocki),[17] giving a sense of the midday heat and the clear air. The description of the *Sower*, however, reveals Vincent's plans for a monumental, programmatic version departing from any notions of realism in color. This description is itself something akin to a manifesto: "I would much rather make naïve pictures such as those found in old 'farmers' almanacs,' in which hail, snow, rain, and fair weather are depicted in a wholly primitive manner," as he told Bernard. This declaration of allegiance to such basic, one could even say symbolist, notions of pictorial composition pointed towards a change which was to define the next stages of his work. "One's sight changes," he had written to Theo, "you see things with an eye more Japanese, you feel color differently.... I am convinced that I shall set my individuality free simply by staying on here."

Real Life

"More worth while to work in flesh and
blood itself than in paint or plaster."

"Like everyone else," as Vincent van Gogh wrote to Theo from Belgium in August 1879,[18] "I feel the need of family and friendship, of affection, of friendly intercourse…" In Arles, about nine years later, although this need had not simply evaporated, the painter was now resigned to the fact that he would probably always have to do without a share in "ideal" or even "real" life. While he was still in Paris he had boasted about his "most impossible, and not very seemly, love affairs," although only one of these has come even dimly to light. Every time when he fell in love with a woman, he instantly had marriage in view—but never quite had the opportunity.[19] And so it was that in Arles the "Japanese" painter, "living close to nature like a petty tradesman," only once waxed lyrical about the opposite sex ("a pretty woman is a living marvel"), and otherwise only reported on visits to brothels to "women at two francs." "The whore," he explained to his friend Bernard, "… has more of my sympathy than my compassion. Being a creature exiled, outcast from society, like you and me who are artists, she is certainly our friend and sister."

Since he had no choice, Vincent viewed artistic production and sexual activity as incompatible ("painting and screwing a lot are not compatible") and insisted that he was "almost as happy as I could be in that real life." But he did only say almost. He always had the sad feeling that he was not taking part in real life, that it would in fact be better to "work in flesh and blood itself than in paint or plaster," by which he meant that it was in fact better "to make children than pictures or carry on business." In rare moments of euphoria, perhaps when he was happy with a picture, he would be uplifted by the thought of "the victory" of "the Impressionist cause" and the hope of his own breakthrough as an artist, for example at the planned 1889 World Exhibition in Paris. When things were going well, he would indulge in thoughts of strategies for his artists' co-operative, a producers' gallery, and his studio in the South. In the late summer he lovingly furnished and decorated the Yellow House with "every-

thing…having character." But when his spirits were low, he would say: "Fortunately for me, I do not hanker after victory any more, and all that I seek in painting is a way to make life bearable." And as he said elsewhere: "I *hope* the *desire* to *succeed* is gone, and I work *because I must*, so as not to suffer too much mentally, so as to distract my mind." In these moments he wanted nothing for himself: all the fruits of his perseverance were to fall to the artists of future generations, while he himself wanted to withdraw into another region of life–"another hemisphere, invisible it is true…where one lands when one dies"–"…but looking at the stars," he confessed to Theo, "always makes me dream, as simply as I dream over the black dots representing towns and villages on a map. Why, I ask myself, shouldn't the shining dots of the sky be as accessible as the black dots on the map of France? Just as we take the train to get to Tarascon or Rouen, we take death to reach a star."

He was often at odds with the planet on which he lived. He viewed it as a study by God which, bless him, "didn't come off. What can you do with a study that has gone wrong?–if you are fond of the artist, you do not find much to criticize–you hold your tongue." But Vincent wanted to see other works "by the same hand though; this world was evidently slapped together in a hurry on one of his bad days, when the artist didn't know what he was doing or didn't have his wits about him." Comparing the Earth's creation with making paintings was quite clearly bordering on blasphemy, and Theo's response has not survived.

At any rate, Theo was supportive and patient towards Vincent while he was in Arles, and during this time–but *only* during this time–there was truth in the now widespread myth of indestructible brotherly love, portrayed as it is in films and novels: a "stormy passion" (Pierre Leprohon)[20] between the "Christ-Man" (a term devised in 1914 by the art writer Julius Meier-Graefe)[21] and his mentor in Paris. In the past, on the other hand, they had had severe quarrels, with the constant underlying threat of war between the two brothers, and with Vincent risking a complete break with his benefactor simply out of hurt pride.

When Vincent had failed in Borinage in his attempt to become a missionary, Theo had appeared on behalf of the family to give career advice. Baker, lithographer or librarian were his suggestions for putting an end to his brother's "idleness." Vincent's response to this

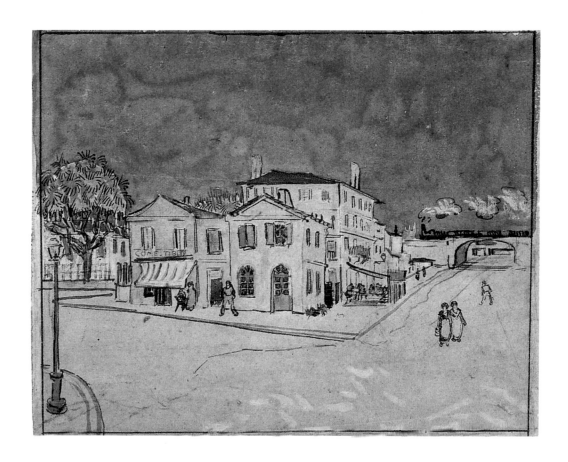

*Van Gogh's House
(The Yellow House),
1888*

tactless use of language by his brother was to stop writing to him for a whole year. Later, after their reconciliation and his decision to follow a career as an artist, Vincent lived off Theo's money in The Hague with the prostitute Clasina Maria ("Sien") Hoornik. He wanted to marry her and to provide for Sien's two illegitimate children, but his brother came to negotiate with him and to persuade him to renounce this potential misalliance abhorred by all his relatives. At the beginning of 1884, when Vincent was painting in Nuenen (in Brabant), he had an argument with Theo about money; his letters became sharp and resentful: "…if you do not do anything with my work, then I do not cherish your protection…. In the matter of that woman you also got what you wanted, but…I am damned if I care to receive a little bit of money if I have to practice morality in exchange… a *wife* you cannot give me, a *child* you cannot give me,

work you cannot give me. Money, yes….The way to remain good friends is to part company." Of course it did not come to separation because Theo who did deeply admire and love his brother would not give Vincent up. Yet in the time to come there were still irritated letters, for example from Antwerp, and in Paris Vincent's egoism made living together in their shared flat difficult. In 1887 Theo complained in a letter to their sister Wil: "There was a time when I thought very highly of Vincent and when he was my best friend but that time is now past… It is as though there were two individuals inside of him—one hugely talented, fine and tender, the other egoistic and hard-hearted!"

The argument in Nuenen led to a written agreement, which Vincent still considered valid in Arles: "… to avoid further discussion or quarreling, in order to have some answer when those leading ordinary lives accuse me of being without any 'source of income,' I want to consider the money I receive from you as money I have earned! Of course I will send you my work every month. As you say, that work will be your property then…." And Vincent kept strictly to this. He conscientiously sent off almost his entire output of pictures in three large consignments, meanwhile posting his rolled-up drawings and referring pointedly in almost every second letter to their business arrangement: "… consider these pictures as a payment to be deducted from what I owe you, then, when the day comes when I'll have brought you in something like 10,000 francs in this way, I'll feel happier." But Theo did not rise to the bait and feigned ignorance: "… really, you are making too much of something which is entirely natural, without taking into account that you have repaid me many times over, by your work as well as by your friendship, which is of greater value than all the money I shall ever possess." From March 1888 to April 1889, Theo (whose own yearly income was 7,000 francs plus commission) sent 2,300 francs to Arles in letters, or by telegram or postal order—not counting the many rolls of canvas and almost all the paint, which Vincent needed for the around 200 pictures he produced during this period.[22] The painter expressed his sincerest gratitude for this, sent receipts for all larger expenses, and shared his hope of future success in a brotherly manner: "But once they [my pictures] are worthy, I swear that you will have created them as much as I, and that we are making them together." Vincent always started to worry when he had a moment away from his work.

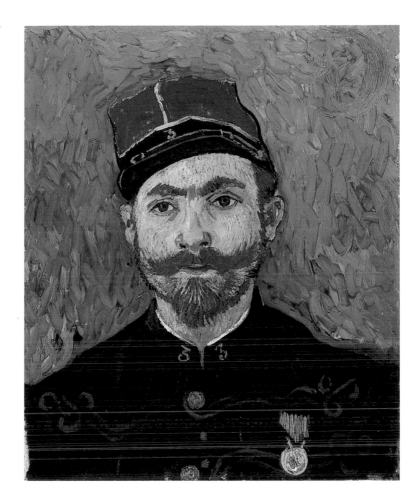

He worried about Theo's health and his possibly insecure position at work because of a disagreement with his superior. He was anxious about his own health – mentioning it over 40 times in his letters from Arles – suffering as he did from stomach pains, lack of appetite, toothache, and eye strain. He was anxious about his sister Wil ("Ah, if she could marry an artist, it wouldn't be such a bad thing for her"). And he was anxious about the difficulty of finding models to sit for portraits, about trivial everyday things like looking for a restaurant with better food. He would also become downcast when anyone tried to charge him too much: when the owner of the Hotel Carrel tried to overcharge him, Van Gogh took him to the local arbitrator. Vincent was instantly awarded a reduction of twelve francs on his

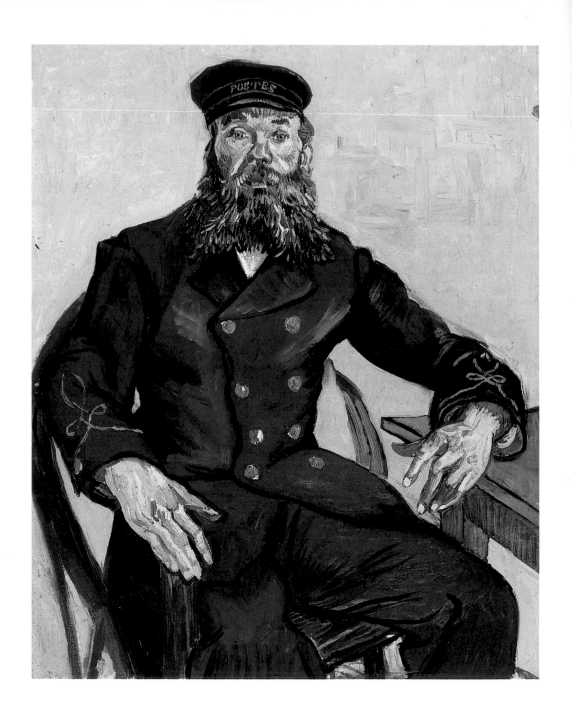

Joseph Roulin, Sitting in a Cane Chair, 1888

bill, but nevertheless still moved in to the Café de la Gare, run by Joseph and Marie Ginoux, who put him up for 1.50 francs a night until he was able to spend his first night in the Yellow House on September 17.

However, it was his loneliness that caused him the greatest distress in Arles, where even after months "everything" still had a "battered and sickly look about it." He did read a lot, and wrote about 200 letters (most of them in French), but – "a terrible handicap for me" – he could not talk to most of the people living there because he did not understand the Provençal dialect. So, for example, in July "often whole days pass without my speaking to anyone, except to ask for dinner or coffee. And it has been like that from the beginning." Up until the autumn, he had serious conversations with no more than five men. Only two of these were locals – the Second Lieutenant Jean-François Milliet of the 3rd Regiment of Zouaves, and the postal worker Joseph-Etienne Roulin. Milliet, who was moderately inter-

Joseph Roulin,
Head, 1888

ested in art, took drawing lessons with Van Gogh, went painting with him to Montmajour, delivered a roll of pictures to Theo in Paris, and found a regimental bandsman to sit for him in his splendid uniform. Milliet himself was also painted by Vincent ("If he posed better…") before he was detailed to Africa (see illus. p. 59). Roulin ("very like Socrates… more interesting than most") was also the subject of eight works including drawings and paintings, and little by little, Van Gogh made portraits of the whole family (see illus. pp. 60, 61). The three other people he had conversations with were foreign painters passing through the town.

From March until May he had the company of the Danish artist Christiansen Mourier Petersen, whose work seemed "dry, correct and timid" to Vincent. But because the Dane was able to share Van Gogh's enthusiasm for his favorite authors–Emile Zola, Edmond de Goncourt, and Guy de Maupassant–Van Gogh called him "my [Danish] friend" and recommended him to Theo, who did indeed let him stay with him for a while in Paris. Vincent found himself rather less at ease with a 28-year-old friend of his colleague John Russell: as he mocked, the American Dodge MacKnight would "soon be making little landscapes with sheep for chocolate boxes," but noted with pleasure that the "Yankee" did praise his work. MacKnight's traveling companion, the 33-year-old Belgian painter Eugène Boch, on the other hand, was a sheer delight even for his physiognomy alone. In early July he repeatedly described to Theo the "face like a razor blade" and the "head rather like a Flemish gentleman." Four weeks later he surprised him with a minute description of a painting that did not yet exist: "I should like to paint the portrait of an artist friend, a man who dreams great dreams, who works as the nightingale sings, because it is his nature. He'll be a blond man. I want to put my appreciation, the love I have for him, into the picture. So I paint him as he is, as faithfully as I can to begin with. But the picture is not yet finished. To finish it I am now going to be the arbitrary colorist. I exaggerate the fairness of the hair, I even get to orange tones, chromes and pale citron yellow. Behind the head, instead of painting the ordinary wall of the mean room, I paint infinity, a plain background of the richest, intensest blue that I can contrive, and by this simple combination of the bright head against the rich blue background, I get a mysterious effect, like a star in the depths of an azure sky."

Portrait of Eugène Boch, 1888

When this vision then became the *Portrait of Eugène Boch* (illus. p. 63) in September, there were indeed stars rising beyond the aureole outlining his head. But Boch, who Vincent got on well with, and who went with him to the bull-fighting, as a painter sadly produced only somewhat "tame Impressionism." Van Gogh, however, liked his "very sensible ideas": for example, Boch wanted to settle shortly in Borinage and paint the miners. In his imagination, Van Gogh was already seeing this as a northern "post among the coal mines"–the counterpart to the Yellow House in Arles.

In Arles, unlike when he was in Paris, Vincent van Gogh practically never had the opportunity to see works of art by which he could set his own course or measure his progress. All that Theo could send him were journals, books, a few lithographs, photographs and Japanese prints. By dint of necessity, therefore, his astonishing ability to instantly recall things that he had seen years before now came into its own–in his letters he writes about pictures by Frans Hals, Rembrandt, Delacroix, Monticelli, and many others, referring accurately to details of color and composition (insofar as these were relevant to his own work). Besides this he encouraged his painter friends to exchange drawings, landscapes and self-portraits; that worked from the earliest days with Bernard, and in the end even with Paul Gauguin, who was for Van Gogh the most impressive of all his contemporaries.

The onetime sailor had worked his way up in the Paris Stock Exchange to a yearly income of 40,000 francs. Then as a collector and gifted amateur painter (attending courses at the private Colarossi Academy), he had encountered the Impressionists. When he lost his position after the Stock Exchange crash of 1882 and could not find a new one, he decided to make his hobby his profession, only to run straight into severe difficulties. For the same held for his pictures as Vincent had found for his own: "… most of the people intelligent enough to like and understand impressionist pictures are and will remain too poor to buy them." Van Gogh himself, who had been introduced to the unashamed egomaniac in Paris by Bernard, loved Gauguin's pictures. At the beginning of April he wrote enthusiastically to Bernard: "Everything his hands make has a gentle, pitiful, astonishing character." But admiration became self-deprecation when he addressed the Master himself: "I always think my artistic conceptions extremely ordinary when compared to yours," he wrote

Paul Gauguin
Self-Portrait, 1888

at a time when he was producing his best work in Arles, "I have always had the coarse lusts of a beast."

At the time Gauguin was painting in the artist's colony in Pont-Aven (in Brittany). He was ill and so deeply in debt again that at the end of February he turned to Vincent, asking whether he could not put a good word in for him with Theo. This cry for help led to a considerable volume of correspondence, which did not come to a conclusion until the autumn, and which at times took on all the grotesque characteristics of an exchange of diplomatic notes between minor nations. And yet the interests of the various parties were perfectly clear: Gauguin at a financially low ebb ("nil is a negative force") wanted to set up a business partnership with the art dealer Theo van Gogh, and was hoping for a quick return from sales. Theo, on the other hand, who thought highly of Gauguin's work, but could neither guarantee a return nor offer an advance, put a different proposal to Gauguin at the end of May. This was also what Vincent wanted: Gauguin was to go to Arles, move into the Yellow House, paint alongside Vincent, and send one picture a month to Theo in return for food, lodging and materials. This then is what happened — but only after Gauguin had initially not reacted at all, then agreed in

65

principle, but kept the date of his arrival open, and had furthermore attempted to set some additional financial conditions in view of his crippling debts. Even Vincent lost patience with his idol when Gauguin, bankrupt as he was, reacted to the wonderful plan for an artists' cooperative with the counter-suggestion that they should first raise "capital of 600,000 francs." As far as Vincent was concerned, this was no more than trying to build "a fata morgana," and he scornfully drew back from "Gauguin and his Jewish bankers."

The moment Gauguin had indeed agreed to the proposal, Vincent, despite everything, increased the already frightening rate of his artistic output: "I have no time to think or feel, I go on painting like a steam engine." He was determined that, when his guest arrived, he would "be able to show him something new, and not be subjected to his influence… before I can show him indubitably my own individuality."

Truer Colors

"Blazing orange like red-hot iron."

Vincent van Gogh's conduct as an artist was exemplary. Unlike his dealings in his generally miserable, often chaotic, day-to-day existence, once at the easel he knew exactly what he wanted. Even as a novice he had wisely guarded against trying to run before he could walk, and later on the autodidact was less concerned to create an interesting style than to discover the truth of his works in the spirit of his champions Delacroix and Millet. Although it is true (as anyone can see or at least read about today) that he did revolutionize the painting of his day, together with other great figures such as Paul

La Mousmé, Sitting in a Cane Chair, 1888

67

Cézanne, Paul Gauguin, Odilon Redon, and Georges Seurat, setting the course for the avant-garde of the twentieth century, he himself would most probably not have been happy with the term "revolutionary," for in his words: "I do not see the use of so much sectarian spirit."[23] It goes without saying that he was on a collision course with the dogmas of academic correctness, and as early as 1885 in Holland accepted that his work would contain "deviations, remodelings, changes in reality." But these formal "incorrections" should never be permitted to become the end rather than the means. Vincent was prepared to accommodate these "yes, lies if you like," if need be, as the necessary prerequisites of a work of art, which itself was above all intended to be "truer than the literal truth."

Van Gogh did not allow himself to be thrown off course in this endeavor–neither by his encounter with Impressionism nor by his increasing technical assurance, even mastery. In the summer of 1888 he set out his priorities. At last he had the chance to prove himself in the genre which he regarded most highly of all: the portrait–for it "makes me feel the infinite more than anything else." From the end of June until September 1888, he was able to find sitters in Arles and painted portraits. He made likenesses of the Regimental Trumpeter Bugler from the Zouaves, of an unknown Provençal girl, La Mousmé (see illus. pp. 67, 69), of the postman Joseph Roulin (see illus. pp. 60, 61), of the peasant Patience Escalier, of the Second Lieutenant Paul-Eugène Milliet of the Zouaves (see illus. p. 59), and of his Belgian colleague Eugène Boch. In addition to this, he made two self-portraits and–from a photograph–a portrait of his mother, who was then 69 years old.

"…To paint human beings, that was the old Italian art, that is what Millet did and what Breton does," he had declared enthusiastically in Antwerp at the end of December 1885, formulating the credo of his approach to the human form: "The question is only whether one starts from the soul or from the clothes, and whether the form serves as a clothes peg for ribbons and bows or if one considers the form as the means of rendering impression and sentiment, or if one models for the sake of modeling, because it is so infinitely beautiful in itself. Only the first is transitory, and the latter two are both high art." For Vincent this notion of the infinitely beautiful applied above all to Nature. At times he could be excited by Nature to the extent that he would "lose consciousness," and then simply

La Mousmé, Sitting in a Cane Chair, 1888

had to absorb these landscapes one after the other till exhaustion overcame him. In these cases, his own reaction to Nature dictated what he must do. Portraits, on the other hand, while of necessity still inspired, offered him a much more consciously calculated form of expression.

"Brains" were what the portrait of the young girl from Arles required of him when he was let down by the technical virtuosity which he had come to take for granted. To his annoyance, it took Vincent a whole week to paint his *La Mousmé* (the name given to young Japanese girls by the writer Pierre Loti in his novel *Madame Chrysanthème*). And "not having been very well either," he had not done as much as he would have liked, feeling he "should have attacked some landscapes" in between times, which would have given him more of a sense of achievement. It is clear, however, that he viewed the tedious work on the three-quarter figure as nevertheless well worth the effort because he reported immediately on it to Theo and Bernard, and his sister Wil. What mattered to him most about this work is recorded on a pen and ink sketch of the same subject, which has notes in the border on the colors used—from Verona green to bloodred to orange. He did not refer to his deviations from reality: the cane chair is over-sized, with its curved back protectively encircling the tender figure, and "the charming little hand" mentioned in his letter to Bernard is so unnaturally long and slim that one's eye is instantly drawn to it. A drawing of the head and upper

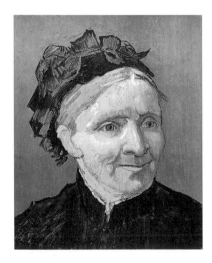

Portrait of Van Gogh's Mother, 1888

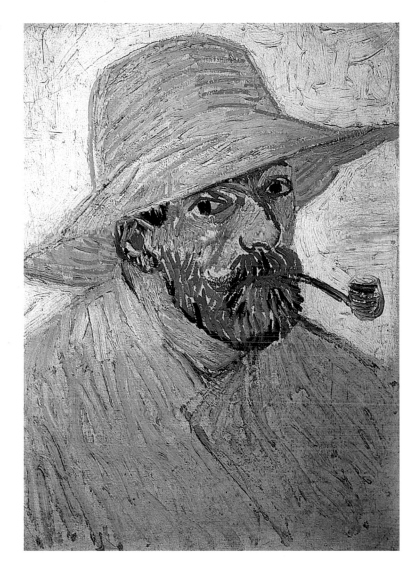

body of *La Mousmé*, which Van Gogh sent to his friend John Russell, must be one of his most beautifully drawn portraits his.

A striking contrast to the elegant simplicity of the portrait of the girl is then evident in the portraits of grown men carried out immediately beforehand and afterwards. With reference to his *Half-Length Portrait of the Zouave Bugler* (illus. p. 72), Van Gogh spoke of "a savage combination of incongruous tones." Meyer Schapiro praises the second, full-length portrait of the same figure with "im-

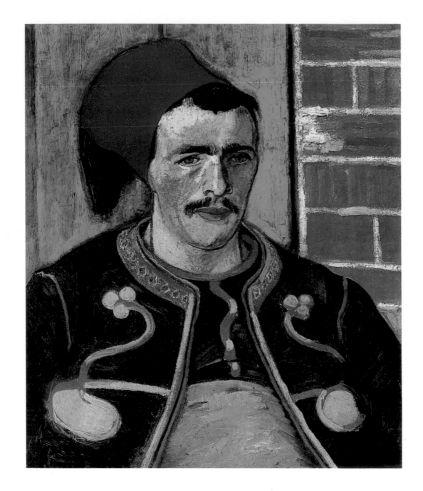

*Half-Length Portrait of
the Zouave Bugler, 1888*

mense" bright red trousers as a "brilliant, original work," an "ingeni-
ous construction."[24] Together with the portrait of Joseph Roulin–
postal worker, family man, republican and drinker (with Van Gogh
repeatedly referring in his letters to his "Socratic" qualities)–Vin-
cent's studies of the Zouave answered a sudden urge towards stron-
ger expression: as he wrote to Theo, "I'd like always to be working
on vulgar, even loud portraits like this. It teaches me something, and
above all that is what I want of my work."

Taking this into account, and in Van Gogh's own terms, *The Old
Peasant Patience Escalier* (illus. p. 75)–above all in the second version
where the man's hands are clasped over the walking stick–turned
out much harsher and more vulgar than all his portraits to date.

Viewers today will hardly see the sense of this pejorative language, which should perhaps be taken as self-deprecation, contrasting as it does with the strong terms Van Gogh used to describe the colors used for the "man I have to paint, terrible in the furnace of the height of harvest time": "the orange colors flashing like lightning, vivid as red-hot iron... luminous tones of old gold in the shadows." And boldly he ranked this "picture of the old peasant's head" above his *Sower* from June, that he had been so proud of.

With a newfound level of self-confidence as an artist, he wrote about this work to his brother in such a way that Theo could hardly wait to see the picture—"I do not think my peasant would do any harm to the de Lautrec in your possession"—and at the same time explained that he was moving away from Impressionism as a program: "It is only that what I learned in Paris is leaving me," he wrote, "and I am returning to the ideas I had in the country before I knew the impressionists." Once again questions of technical finesse took precedence; he wanted "to find a special brushwork without stippling or anything else." What he wanted was "nothing but the varied stroke." He did not object to the discoveries of his valued friends Seurat, Signac, and Anquetin: their "stippling and making halos and other things, I think they are real discoveries, but we must... see to it that this technique does not become a universal dogma...." In the two versions of the *Escalier* portrait, which manage with virtually no Impressionist mannerisms, such as commas and color-fields of dots, Van Gogh had shown how securely he now stood on his own two feet. Almost lightheartedly he now raised the stakes for himself—in theory and in practice.

On August 11 he noted down how he imagined his portrait of his colleague *Eugène Boch* (illus. p. 63); then on September 2 he painted "this picture... that I have been dreaming about for so long." After two sittings on the same day, the result was in fact as Van Gogh had described it on paper: "His fine head with that keen gaze stands out in my portrait against a starry sky of deep ultramarine.... Oh my dear brother, sometimes I know so well what I want." This very real success awakened in the artist a sense of the as yet untapped ideas and potential within himself, and so in the same letter he wrote of what he wanted in terms that distanced him yet further from Impressionism: "I want to paint men and women with that something of the eternal which the halo used to symbolize, and which we try to

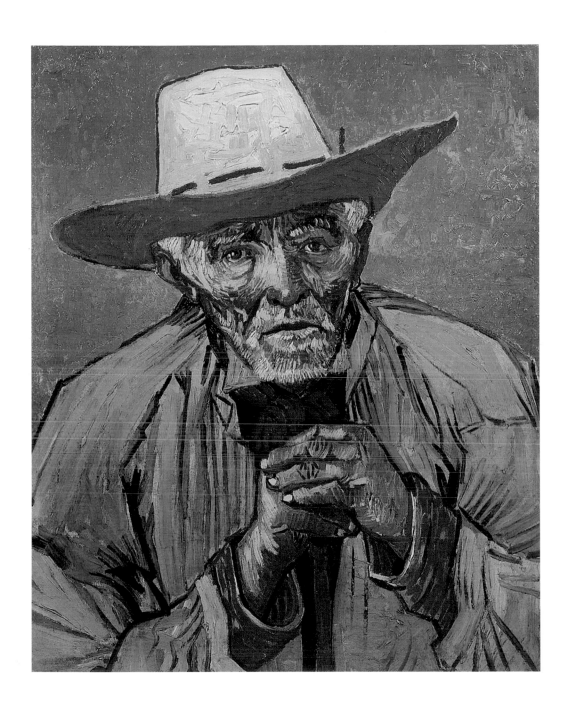

The Old Peasant Patience Escalier, 1888

convey by the actual radiance and vibration of our coloring." Once again the artist revealed himself as the onetime preacher who was overwhelmed again during these weeks by "a terrible need of...religion"; in his talk of religion, the painter, whose uncouth *Potato Eaters* (illus. p. 21) were yet clearly symbolic of the eternal quality of life on the land, was taking up a familiar theme–but despite this, things were quite different in that late summer in Arles. Vincent van Gogh felt himself gripped by the properties of color more intensely than he had ever felt before, and was moved to write to Theo about this revelation.

Unable to contain his excitement, Van Gogh wrote in prophetic terms of the ideal "portrait–showing the model's soul" and, during the course of that particularly lengthy letter (No. 531), as yet unthought of and untried possibilities of color symbolism came to him: "So I am always between two currents of thought, first the material difficulties, turning round and round to make a living, and second, the study of color. I am always in hope of making a discovery there, to express the love of two lovers by a wedding of two complementary colors, their mingling and their opposition, the mysterious vibrations of kindred tones. To express the thought of a brow by the radiance of a light tone against a somber background. To express hope by some star, the eagerness of a soul by a sunset radiance. Certainly there is no delusive realism in that, but isn't it something that actually exists?"

As Uwe M. Schneede concludes: "Van Gogh's unique historical significance is that, aware of the actual qualities of colors–as attached to objects–he was able to make them speak."[25] How precisely and comprehensibly color symbolism can speak to the viewer–whether, that is, a picture will convey a sense of the spiritual, of hope, or of passion–must be left to the individual to decide, who in turn has to bear in mind the artist's own explicit self-interpretation which cannot be ignored and which may indeed not always be helpful. Van Gogh's words mark the onset of a discussion which came into being with modern art and which has by no means run its course yet: now for the first time the question was raised as to modern art's need for external comment. In addition to a knowledge of the meaning of various motifs, now a knowledge of a work's structural principles and of the artist's intentions have become indispensable for the public: the viewer is invited into partnership with the

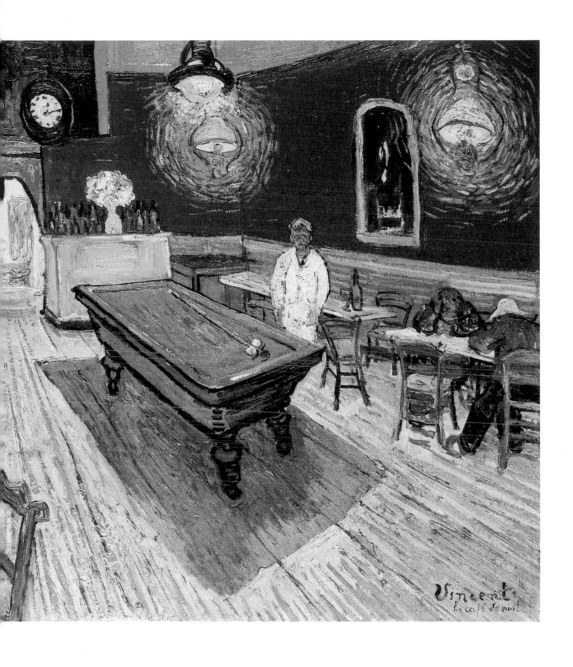

The Night Café, 1888

Overleaf: *The Dance Hall in Arles, 1888*

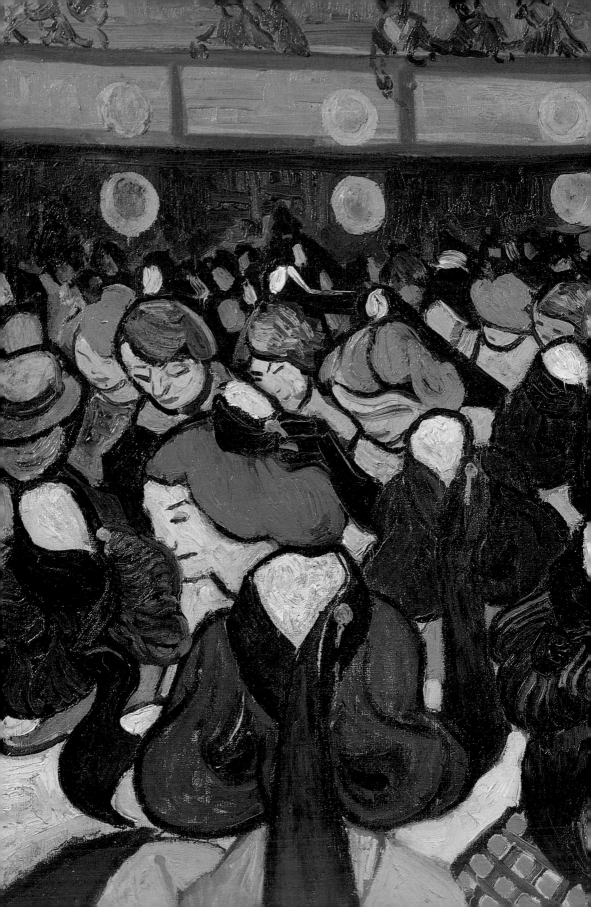

artist. The work of art is incomplete without the viewer's active participation. The basic problem of "how to make the color and all the other pictorial elements speak also means…re-inventing painting picture by picture."[26]

The works which Van Gogh produced in the autumn of 1888 at the same time as his portraits present, if any, only minor difficulties for viewers today. The audacity of their composition, the radical use of color, their assured handling of the subject matter, and their intensely painterly qualities simply sideline questions of intended symbolism and just prove the artist right: "The studies now are really done with a single coat of impasto." And then at beginning of April Vincent felt a particular need: "I must also have a starry night with cypresses…there are some wonderful nights here." After a walk along the beach at night in Les-Saintes-Maries-de-la-Mer, he reported on June 16: "In the blue depth of the stars were sparkling, greenish, yellow, white, pink, more brilliant, more sparklingly gemlike than at home…opals you might call them, emeralds, lapis lazuli, rubies, sapphires…"

Café Terrace at Night,
1888

Facing page:
Café Terrace at Night,
1888

Overleaf:
The Starry Night
(Starry Night by the
Rhône), 1888

At the beginning of September he worked at night too: he stayed up for three consecutive nights to paint the Café de la Gare, owned by M. and Mme. Ginoux, with whom he was boarding until the Yellow House would be ready in September. He described this "night café" as somewhere for drinkers who "have no money to pay for a lodging or are too tight to be taken in," calling it "a place where one can ruin oneself, go mad or commit a crime": in the center a billiards table rises up like a catafalque–the only item of furniture beneath the gas candelabra, casting its shadow across the room. Red, green and yellow dominate in this box-like room with its "atmosphere like a devil's furnace." When he was not painting there he was there as a customer. A good week later Vincent again sacrificed his sleep and created another of the works, which link artifice and sensation so closely together that a hundred years later any man or woman in the street will still be moved by this "night picture without any black in it": the *Café Terrace at Night* (illus. p. 81) is an outdoor interior. The blazing, golden yellow light from a gas flare serves to enclose the drinkers like protective walls. The facades of the houses along the cobbled street bluely reflect the comforting glow and frame the scene in a manner which is friendly. And in the royal blue heavens, the stars that looked like precious stones in Les-Saintes-Maries seem like nearby havens just waiting there for anyone who should wish to escape. As Van Gogh wrote to his sister Wil: "It amuses me enormously to paint the night right on the spot... it is the only way to get rid of the conventional night scenes with that poor sallow whitish light...." He also wrote that the idea for the subject matter had come from Guy de Maupassant, who described "a starlit night in Paris with the brightly lighted cafés of the Boulevard" in the opening of his novel *Bel Ami*.[27] For the first time ever, Van Gogh discovered a notice in the local press about his work,[28] describing these nighttime activities of his in Arles–once he even mistook "blue for a green" in the darkness. And then in September he created the most outstanding piece of all his nighttime works: his *Starry Night* (illus. pp. 82-83).

Night has many colors in this deeply serious picture with the lovers in the foreground, the sailing boat at the riverbank, and the silhouette of the town on the horizon. In a letter to Theo, the painter lists all the colors used: "The sky is greenish-blue, the water royal blue, the ground mauve. The town is blue and violet, the gas [light] is yellow and the reflections are russet-gold down to greenish-bronze."

The Starry Night, 1889 But, as Jan Hulsker puts it, "never before had he departed so drastically from reality"[29] as in his depiction of the sky: there the stars, without any regard to real distances, look down even more warmly on the town dwellers than in the picture of the *Café Terrace*. Van Gogh described it himself: "On the blue-green expanse of the sky the Great Bear sparkles green and pink, its discreet pallor contrasts with the harsh gold of the gas." Vincent's hero Millet had also painted a star studded sky, and a proper picture was most definitely to follow on the study. Van Gogh then did indeed carry this out nine months later in the sanatorium in Saint-Rémy, and his *Starry Night* was to become a magically expressive masterpiece as well as the most perplexing of his best known works. Another night piece, on the other hand, *Christ with the Angel on the Mount of Olives*, he twice scraped uncompleted off the canvas and never again returned to it.

*The Tarascon
Stagecoach, 1888*

Van Gogh's obsession with work made it impossible for him to restrict himself just to nocturnes and portraits, so he also took in and painted what the seasons had to offer: decorative scenes of flowers and vineyards, the public park near the Yellow House and the Yellow House itself, "in sulfur-colored sunshine, under a sky of pure cobalt. The subject is frightfully difficult; but that is just why I want to conquer it"—not daunted by the fact that he was in fact pained by the contrast of the yellow architecture and "the incomparable freshness of the blue." He mastered other new subjects purely for himself, painting railway carriages, coal barges in the evening light, the new Trinquetaille Bridge, and the old Tarascon stagecoach.

Vincent made a self-portrait as *The Painter on the Road to Tarascon*[30] laden with painting materials, painted *Sunflowers*, and his *Bedroom* in the Yellow House, and as rule during this time sent Theo

only sketches of his pictures. He held on to the originals. He had many of them framed because he was in the process of realizing a plan, which, according to Roland Dorn, "was to become the central plank of his pictorial invention in Arles."[31]

The plan had to do with the long awaited arrival of Paul Gauguin in Arles and Van Gogh's wish to display to him his own progress as an artist. It also involved his declared intention to create a southern studio in the Yellow House, a base for other artists passing through the region. In this connection, therefore, the artist was planning a *dé coration*, as it is called in the original French in a letter probably written to Theo on August 21 – in other words, a series of linked pictures which were to "complement each other" (Van Gogh), even forming one "whole"[32] when hung correctly. Initially the *décoration* was to

The Painter on the Road to Tarascon, 1888

87

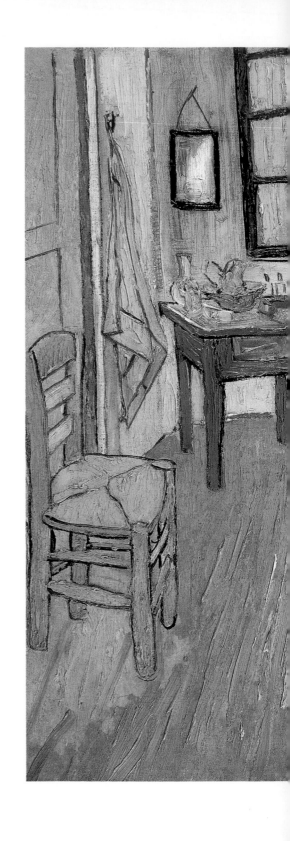

Van Gogh's Bedroom, 1888

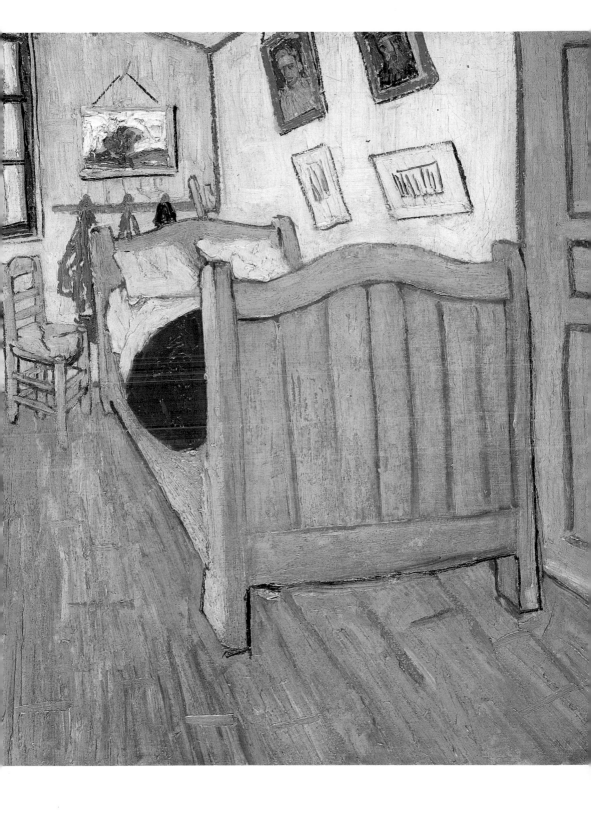

consist solely of the sunflower pictures that he had started to work on at this time. Van Gogh's most famous flower still lifes thus came into being in great haste "for the flowers fade so soon, and the thing is to do the whole in one rush." First there were the *Three Sunflowers in a Vase*, then the six flower heads (two beside the vase),[33] then fifteen,[34] and lastly thirteen (see illus. p. 91)[35]–painted with such variety, each with a different background, letting the flowers sing out as a "*poem of joy*"[36] that Dorn feels "one might view the *Sunflowers*… as an experimental series if Van Gogh himself had not seen them as a *décoration*."[37]

Many more sunflower pictures had been planned, which he intended to hang in the Yellow House "in the Japanese manner" as he explained to his sister Wil: "You know that the Japanese instinctively seek contrasts…. So it follows, according to the same system, that in a big room there should be very small pictures and in a very little room one should hang very large ones." But one morning Vincent had no models any more: the sunflowers were finished. And as the artist made further items for his *décoration* they were all in large format "at 30,"[38] and there was no more mention of contrasting

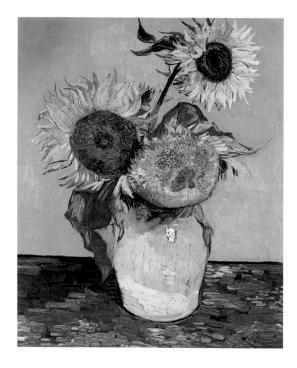

Three Sunflowers in a Vase, 1888

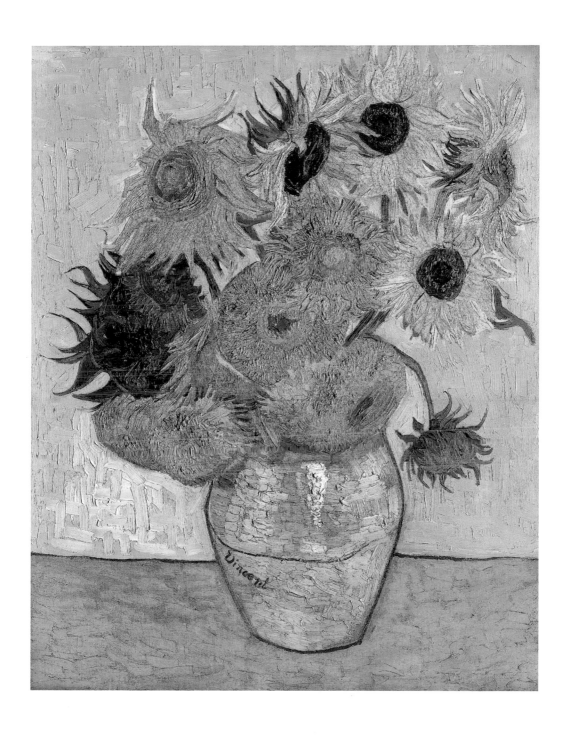

Thirteen Sunflowers in a Vase, 1888

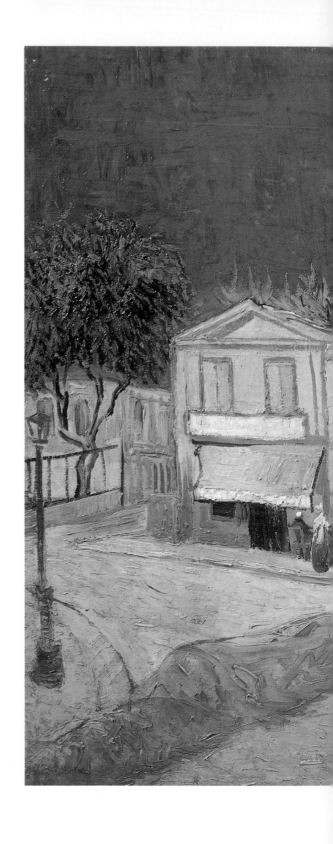

*Van Gogh's House
(The Yellow House),
1888*

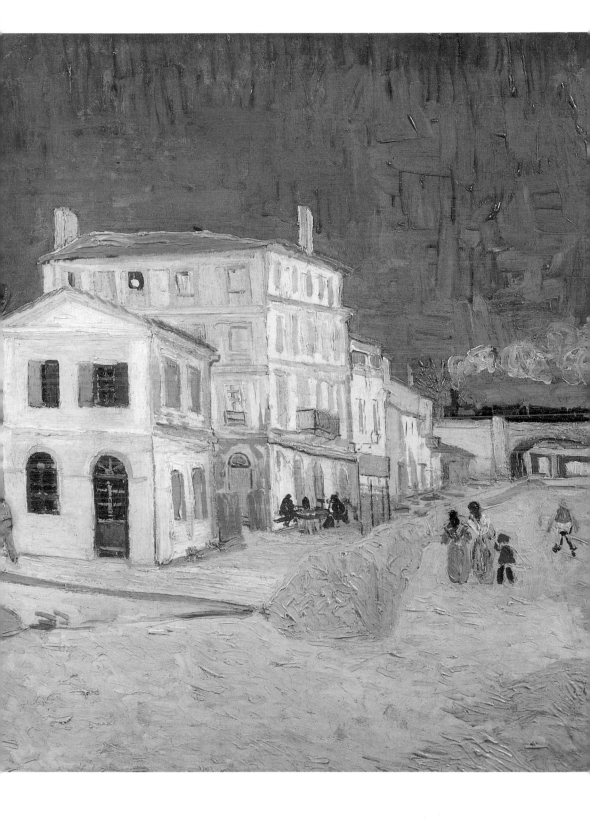

large and small. Amongst other things he also included the *Bedroom* (illus. pp. 88-89). On the short list selected from more than 30 possible contenders were also the *Starry Night*, the *Yellow House* (illus. pp. 92-93) and *Night Café* (illus. p. 77)–not, however, the more impressive of two self-portraits from that summer: it was painted during the same week as the Café Terrace and shows the artist almost bald, wearing a jacket and waistcoat in front of a pale green aureole-like background with sweeping brushwork. "But as I also exaggerate my personality," commented Vincent, "I have in the first place aimed at a character of a simple admirer worshipping the Eternal Buddha. It has cost me a lot of trouble." The confession was to the man whose arrival was imminent and to whom the picture was dedicated with the words: "à mon ami Gauguin."

Self-Portrait, 1888

94

A Complete Void

"Simply an artist's fit."

"So Gauguin is going to join you," Theo van Gogh wrote to his brother on October 19, 1888, and added with some foresight: "it will mean a great change in your life." Paul Gauguin reached Arles at dawn on October 23rd and moved into the Yellow House. Eight weeks later, however, finding his friend Van Gogh's behavior strange, he moved out very suddenly and on Sunday, December 23 moved into a hotel. On the morning of December 24, he learned from the police that during the night Vincent had cut off his left ear "close in to his head" and he telegraphed for Theo to come; two days later he traveled to Paris with Theo, and never saw Vincent again.

The turbulent events, which were to change Van Gogh's existence so radically and ultimately would destroy it, are reported here only superficially perhaps, but nevertheless accurately. In other words, there is no more hard evidence to be had about Gauguin's role—possibly witnessing or even sparking off this crisis; above all, there is no proof that Gauguin's own description of events fits the facts. He did not put it down on paper until 15 years later—and even then would still have been biased. According to Gauguin's portrayal of events in his memoirs *Before and After*, the two painters used to have heated discussions in Arles—and this is confirmed by Vincent—"our arguments are terribly *electric*"—which led to odd behavior on the part of Van Gogh: several times he crept up at night to Gauguin's bed, laughing "madly" one time and apparently writing on the wall the words: "I am the Holy Spirit, my spirit is whole." In the Night Café Vincent, according to Gauguin, threw a full absinthe glass at his head, allegedly the opportunity for the victim to mention the possibility of leaving sooner than expected for Paris. And then on the following evening, that is on December 23, the most threatening attack of all. Gauguin had gone for a walk on his own: "I was already right across Victor Hugo Square when I heard the familiar sound of quick, light, little footsteps. And I turned round at exactly the moment

when Vincent threw himself upon me with an open shaving knife in his hand. All my power must have been in the look I gave him then, because he stopped abruptly and, hanging his head, ran away towards the house.... I promptly went into the nearest decent Arles inn."

But it cannot have been quite like that. Most importantly, it seems that the alleged incident with the shaving knife perhaps never took place. Why should he have said nothing about it when Emile Bernard asked him about the incident immediately afterwards? Bernard referred to the matter in a letter to the critic Albert Aurier on January 1, 1889: "My dear, best friend Vincent is crazy. Since I heard that I have just about been crazy too. I rushed to see Gauguin and this is what he said: 'On the day before I left Arles Vincent ran up behind me—it was night—I turned round because Vincent had been rather strange for a while and I was on my guard. He said to me: 'You are silent, but I will be too.' I went to stay overnight in a hotel." No word of a knife.

There was more on the events of December 23 in a report in the local paper *Le Forum Républicain* on December 30: "Last Sunday at 11:30 at night a certain Vincent Vangogh [sic], a painter born in Holland appeared in Brothel No. 1, demanded to speak to a certain Rachel and gave her...his ear, with the words: 'Look carefully after this object.' Then he disappeared. Having been informed of these occurrences, which could only be the actions of a poor, disturbed creature the police went the next day to the house of the aforesaid and found him lying in bed, showing barely any signs of life. The unfortunate soul was admitted into hospital as an urgent case."[39]

Vincent van Gogh himself could not give an explanation of that fateful day just before Christmas Eve. As he wrote later to his sister Wil: "I didn't in the least know what I said, what I wanted and what I did...and without retaining the slightest remembrance of what I felt." From his letters it is, however, clear that even before Gauguin's arrival he had been in a strange state—in a kind of creative trance, which used to drive him to work "at white heat," not bothering about any other needs. His description to Theo of his situation at the end of September is typical of this: "these four days I have lived mainly on 23 cups of coffee, with bread which I still have to pay for. And "to attain the high yellow note that I attained last summer," he had moreover smoked "innumerable" pipes of tobacco and had drunk

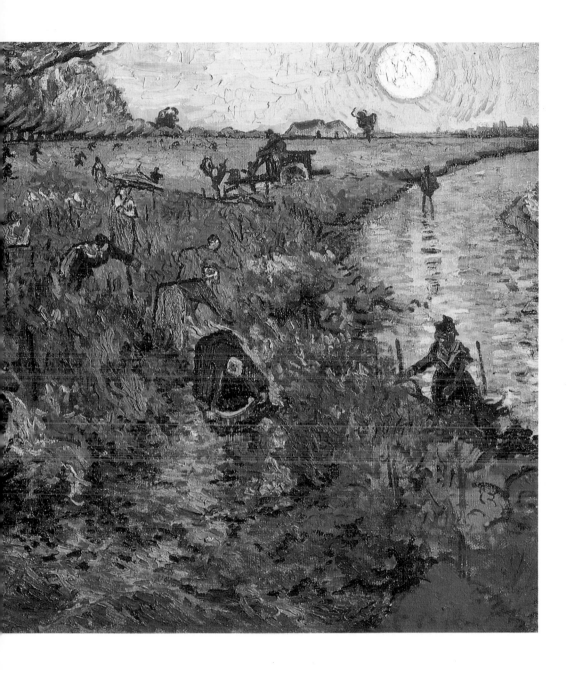

The Red Vineyard, 1888

excessively. He remained in this overwrought state after his friend's arrival. "I myself realize the necessity of producing even to the extent of being mentally crushed and physically drained by it," as he said at the end of October–for he was extremely depressed again about his total lack of financial success: "my debt is so great," he wrote, "that when I have paid it, which all the same I hope to succeed in doing, the pains of producing pictures will have taken my whole life from me." He was afraid of becoming ill; but initially Gauguin took his mind off his problems so effectively that there was a constant flow of magnificent pictures, and his spirits were now not even dampened on rainy days. After a walk with Gauguin, he painted the *Red Vineyard* (illus p. 97) outside; in the studio he made two portraits of the landlady of the coffeehouse, Marie Ginoux (*The Arlésienne*), the perfect tableau of a *Sower* and, completely from his own imagination, the *Memory of the Garden at Etten* (illus p. 100). Gauguin, after all, painted mainly from his imagination, so for his sake Vincent tried the same thing "varying my work a little." However, he did not learn much that was of significance from Gauguin, as the Frenchman later claimed, although he did willingly allow his guest to lure him into making studies in the brothels; he left the cooking and their joint finances up to Gauguin and recorded happily: "we are working hard, and our life together is going very well." Gauguin praised Vincent's sunflower pictures, ranking them more highly than comparable still lifes by Claude Monet. Vincent wrote to Theo about the "very great artist and a very excellent friend": "it does me a tremendous amount of good to have such intelligent company as Gauguin and to see him work."

But at the same time the two men nevertheless regarded each other with suspicion–Gauguin already thought Van Gogh was "sick" before his attack, but did not want "to distress this excellent soul." And a self-portrait that he had sent Van Gogh from Brittany in turn made Vincent anxious. The picture told him that Gauguin "must not go on like this, he must become again the richer Gauguin of the 'Negresses'." To his comfort, Gauguin then told him after a few weeks "that he felt his old self coming back." But in truth the Frenchman felt "very much a stranger in Arles" and found his companion a strain: "Vincent and I generally agree on very little, above all when it comes to painting... for example, in the matter of color, he wants the chance element of thickly applied paint... and I for my part hate

The Arlésienne
(Madame Ginoux)
with Books, 1888

mixing techniques any old how etc." Vincent could tell that his friend was not happy: "I think myself that Gauguin was a little out of sorts with the good town of Arles, the little yellow house where we work and especially with me." His commentary on the situation was two pictures: *Van Gogh's Chair* and *Gauguin's Chair* (illus. pp. 102, 103).

These still lifes of items of furniture from early December 1888 are like coded portraits, forming a diptych despite being so consciously different from one another: one picture is in daylight, the other at night; the tiled floor of one suggests rural simplicity, while something much more intellectual is alluded to in the luxurious carpet and the books on the seat of the chair of the other. The two chairs belong together like Symbolism and Impressionism, as two strands of modern art still looked down upon, as were the friends Van Gogh and Gauguin. The significance of the empty chair as a symbol of death for Van Gogh has been well documented by re-

Memory of the Garden at Etten, 1888

searchers in the field. The art historian Meyer Schapiro also points to the complex composition of the picture of the simple country chair, resulting from the geometry of the wooden struts, the tiles running in the opposite direction, and the right angle drawn on the door.[40] The simpler of the two motifs is thus anything but simple in its execution.

Even if, as might have been the case, the chair pictures had been intended as a plea to Gauguin to stay, he took no notice. In a letter to Theo he gave notice of his intended departure, earlier than planned. He had long had a reason for this: having been forced to go to Arles where the Van Gogh brothers would pay for his keep, the financial crisis, which had driven him to this, was now abating, for in the meantime Theo had managed to sell pictures of his for over 1,000 francs. Gauguin did then hesitate momentarily, and in a second letter retracted his plans to leave as a "figment of his imagination." When Vincent then suffered his breakdown a few days later, he seized the excuse and disappeared without a word of farewell.

Vincent saw this move as betrayal. Sarcastically he called Gauguin "the little Bonaparte tiger of Impressionism as far as … his vanishing, say, from Arles would be comparable or analogous to the return from Egypt of the aforesaid little corporal, who also presented himself in Paris afterward and who always left the armies in the lurch." Yet he did not break off his friendship with the deserter. "We love each other," he wrote at the end of January to "my dear friend Gauguin," … "as I hope enough to start again even now if need be."

At this time Vincent van Gogh was once more "continuing this furious work." He made "quietly composed repetitions" of his sunflower still lifes from August, painted himself with a bandaged ear and a pipe, and most importantly completed the portrait begun before his illness of Joseph Roulin's wife Augustine ("*La Berceuse*"; illus. p. 107). He made five variants of the mother by the cradle of her youngest child Marcelle, and in his imagination flankend this "attempt to get all the *music* of the color" with two sunflower pictures "which would thus form torches or candelabra beside them," nourishing the hope that everything might once again be the way it had been before his faculties began to desert him.

And why not? During the first few days in the hospital in Arles his condition had been so critical that even Theo had given him up for lost: "If he is to find eternal peace, then so be it." But already by

New Year's Eve the patient was improving. Vincent's physician, Dr. Félix Rey, himself only 21 years old, Vincent's friend Roulin, and also the local Protestant clergyman, Frédéric Salles (no doubt called in by Theo), all found him in the best of spirits despite being in the hospital. As early as January 4, he spent a few hours at the Yellow House with Roulin, and on January 7 he was discharged from the hospital. Was he cured? Van Gogh was at any rate enough of a pragmatist to purvey this impression as quickly as possible. He reported to his mother and sister Wil in Holland: "I have completely recovered, and am at work again, and everything is normal." And to his brother he bemoaned the fact that Theo had had "all that

Van Gogh's Chair,
1888-89

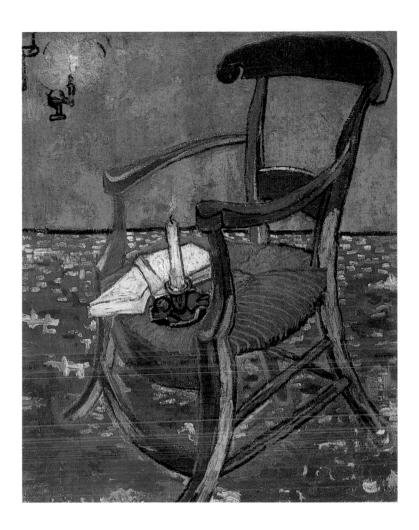

Gauguin's Chair, 1888

trouble for such a trifle" and assured him that this was "a thing of the *past*": "I hope I have just had simply an artist's fit."

A "fit," not madness: there it was again, this defiantly cheerful tone which Vincent had always adopted in the past when he had driven himself too far again, describing himself in a haze of absinthe as "a carcass pretty well destroyed" with "wits pretty well crazed." Semi-seriously and semi-jokingly he would write about "our neurosis, etc." and about the "possibility of going to seed," but beneath the surface was very real fear: "And, if no actual obelisk of too pyramidal a catastrophe [occurs]…." Now in spring 1889 the underlying fear of his own fate had been superseded by painful experience. His fear of a

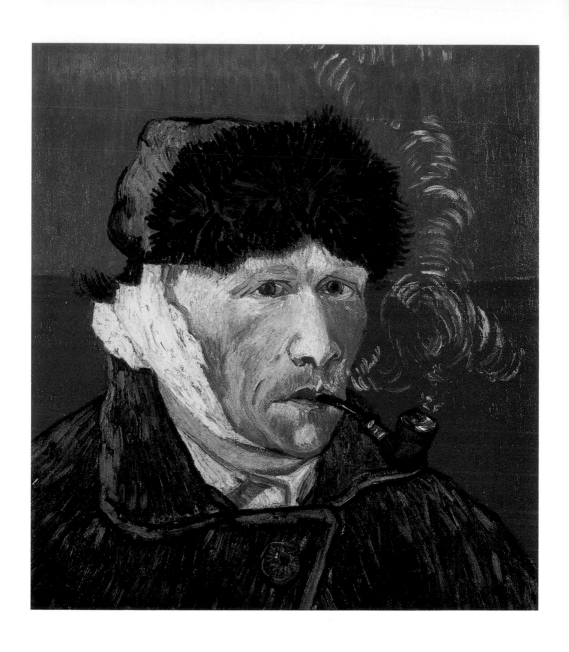

Self-Portrait with Bandaged Ear and Pipe, 1889

recurrence of his illness grew accordingly – the anxiety that the condition might be chronic, transforming a previously "healthy" person into a "case" for the rest of his life.

It happened on February 7, a month after his release from the hospital: Van Gogh was admitted a second time. On February 2 he had already described the symptoms of an attack about to happen: "there are moments when I am twisted by enthusiasm or madness or prophecy, like a Greek oracle on the tripod. And then I have a great readiness of speech and can speak like the Arlésiennes, but notwithstanding all this, I am feeling so weak." Pastor Salles reported that Vincent's cleaning woman had gone to the police and the Chief Commissioner had ordered him to be compulsorily admitted. In Pastor Salles' words: "For the last three days he has thought he has been poisoned and all around him sees nothing but poisoners and the poisoned."[41] A certain Dr. Albert Delon (and not Dr. Rey, whom Van Gogh had in the meantime painted) confirmed this in his report for the authorities, reporting that in addition the patient claimed to hear voices. This second stay in the hospital lasted ten days; the third was the outcome of local protest.

This time Van Gogh had been discharged on February 17, but only "provisionally," and had to suffer adults and children surrounding his house and climbing "up to the windows…as though I were a strange animal." Vincent apparently tried to defend himself and became so conspicuous that, according to Pastor Salles, about 30 of his neighbors[42] sent a petition to the Mayor of Arles, saying that he drank too much, that he had tried to snatch their children and that the women in particular were afraid of him "because," as Salles quoted from the petition itself, "he had taken hold of some of them round the waist, being so bold as to touch them."[43] This time on March 1 or 2 the Chief Commissioner, acting on the Mayor's orders, had the painter locked up in the hospital and sealed up the Yellow House. While Vincent "spent days," as he wrote to Theo on March 19, without tobacco, books or paint, "shut up in a cell all the livelong day, under lock and key and with keepers," Pastor Salles tried on behalf of the authorities to extract a decision from Theo as to the future of the internee. "Are you intending to send for your brother or to find a place for him in an institution of your choice? Or would you rather relieve yourself of this burden and let the police decide? These questions require categorical answers."[44]

Theo seems not to have given any answers at all, just as he had previously been unable to recognize the alarm signals in Vincent's descriptions of his own mental state and to respond to the urgency of the situation then. At the end of July the artist had already described himself as "hopelessly absent-minded," and four weeks later he confessed: "I myself have become haggard of late, almost like Hugo van der Goes in the picture by Emile Wauters." And then on October 8, an accurate premonition of future catastrophes: "I am filled over and over with the terror of these attacks of depression like Meryon's," a remark referring to the fate of an artist colleague who had died in 1868 not in full possession of his faculties. With his knowledge of Vincent's self-mutilation and the subsequent course of his illness, Theo's inactivity seems like a missed opportunity to help, particularly since during those weeks there are continued references in his brother's letters to an approaching state of "madness."

Whether Vincent would have accepted help at the time is, however, another question entirely. In March 1889 at least, when some of the restrictions on his activities had been lifted and he was allowed to read, smoke, and paint again—even to enter the Yellow House during a flying visit by the Parisian painter Paul Signac—he specifically requested that his brother should do nothing. "In the full possession of my faculties and not as a madman," he wrote to his brother: "let things be without meddling." And again at another point in that same desperately sad letter (No. 579): "as for setting me free... the whole accusation will be reduced to nothing." For fear of "strong emotion" which could only "aggravate" his condition, he did not even want to protest against the consequences of what Pastor Salles also felt was unjustified resentment on the part of his fellow citizens, who had robbed him of his freedom: "Besides, humility becomes me after the experience of the repeated attacks. So I am being patient."

He was not able to return to his old surroundings, the Yellow House, because of his hostile neighbors, although his condition had improved to such an extent that Signac was able to write to Theo: "I found your brother in perfect health, physically and mentally." Moreover his landlord had given him notice. Dr. Rey and Pastor Salles found somewhere else for him to live in another part of Arles. Vincent, who was still in the hospital, rented it from the middle of April onwards, but did not move in. As he wrote to Theo, who was

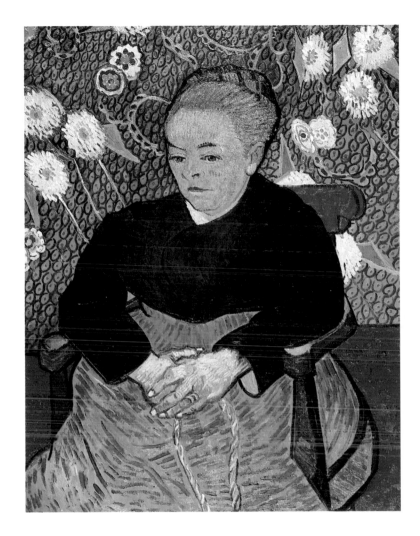

on the point of marrying his Dutch bride Johanna Bonger in Amsterdam, he was "thinking of frankly my role as a madman," and was making a decision: "At the end of the month I should like to go to the hospital in St Rémy, or another institution of this kind, of which M. Salles told me," initially only for three months "as a resident boarder." But if the residential costs should be too high and he were not allowed to go painting outside the institution, he would go instead for four or five years to the French Foreign Legion–the one really crazy notion he had put down on paper since his first attack.

Orchard in Bloom with View of Arles, 1889

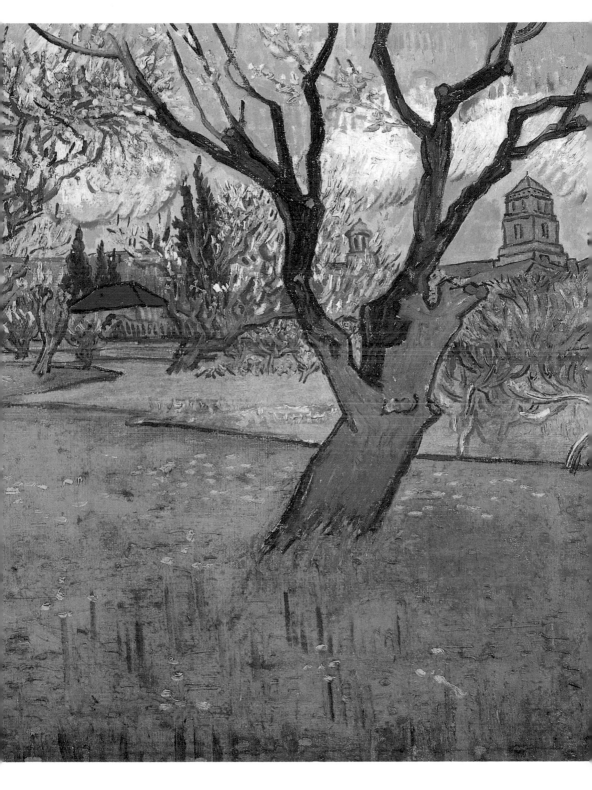

There is something uncanny about the clarity with which he recognized his hopeless position, and the calm with which he accepted the inevitable was superhuman in its aspect: "I am absent-minded and could not direct my own life now." And yet in those last days in Arles he was by no means dull or apathetic—on the contrary, he was actively involved in winding up his studio. He rented storage for his furniture and took the pictures down in the Yellow House—some of them damaged: "the house itself had no fires in it during my absence, so when I came back, the walls were oozing water and salt-peter." He saw the moldy canvasses as symptomatic for the "pitiful, painful failure" of his whole idea: "not only [was] the studio wrecked, but even the studies which would have been a souvenir of it ruined; it is so final, and my enthusiasm to found something very simple but lasting was so strong. It was a fight against the inevitable." He packed

Lane with Chestnut Trees in Bloom, 1889

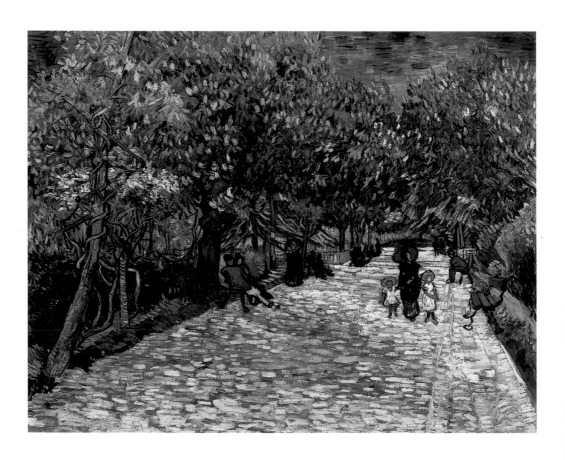

The Courtyard of the Hospital in Arles, 1889

the pictures into two crates and sent them off to Paris, but his "feelings of profound remorse" continued to torment him. In September 1889, when he had long been in the sanatorium, he was still blaming himself for his "cowardice." Why had he not actually met force with force? "I ought rather to have defended my studio, even if I had to fight with the *gendarmes* and the neighbors. Others in my place would have used a revolver, and certainly if as an artist one had killed some rotters like that, one would have been acquitted. I'd have done better that way, and as it is I've been cowardly and drunk. Ill as well, and I have not been brave." This should not be taken literally, nor should the artist be imagined with a revolver at the ready, but it does show with the utmost clarity what the failure of the studio project meant for the artist.

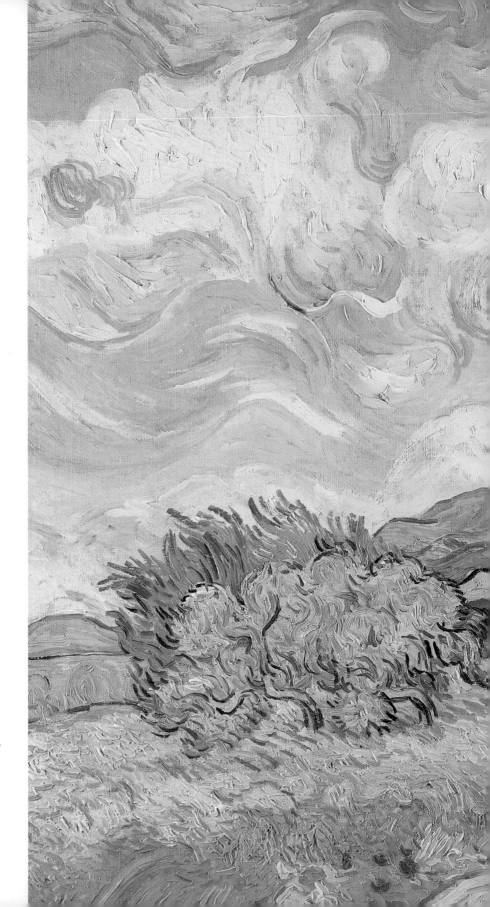

Wheatfield with Cypresses, 1889

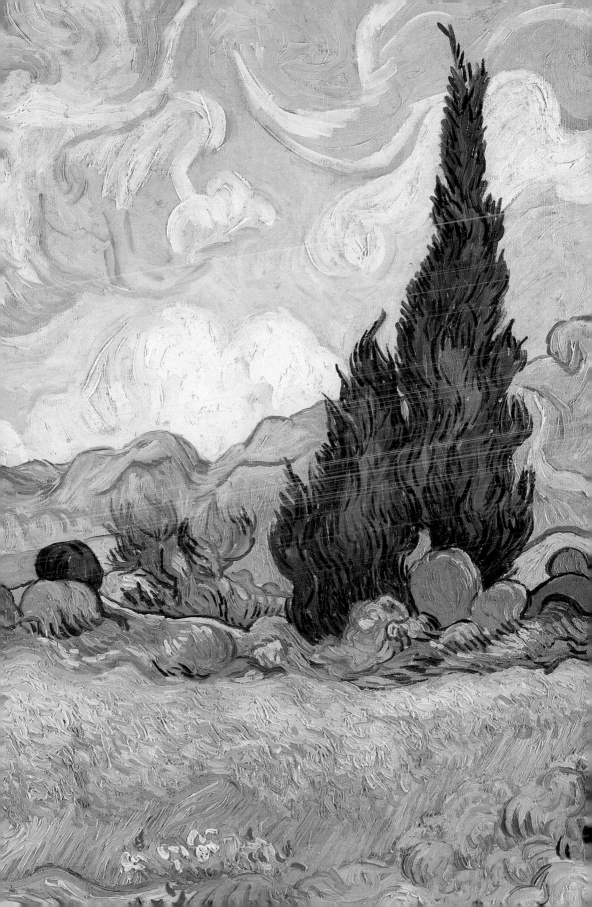

Doctor Félix Rey, 1889

When he arrived in Saint-Rémy on May 8 with Pastor Salles, he was filled with the hope that gradually he could "come to look upon madness as a disease like any other," and equally filled with the belief in the return of his "full creative strength." But these hopes were only to be partly fulfilled because his illness prevented him from working for fifteen of the 53 weeks of his stay there. It was here that his condition was first described in medical terms by the institution's director Dr. Théophile Peyron as "an acute mania with general delirium [and] very irregularly occurring epileptic attacks."[45] And yet the same can be said of the year in Saint-Rémy as for the 69 days of the end of his life in Auvers-sur-Oise—the same as he had once said about his late works in Arles, understating the case as ever: "You will see that the canvasses are not inferior to the others."

Overleaf: *"Les Alyscamps", Avenue in Arles, 1888*

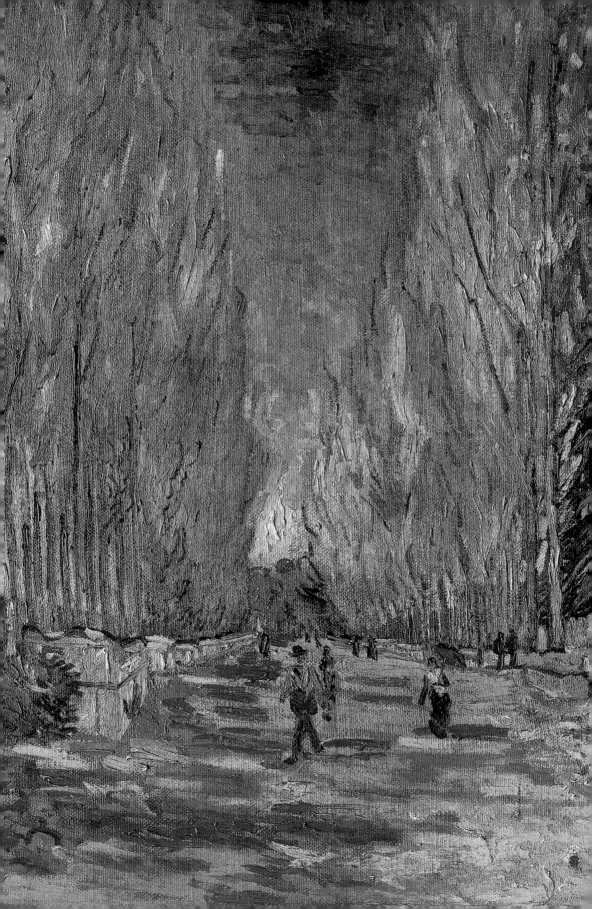

Biographical Notes

Vincent's parents:
Anna Cornelia van Gogh, née
Cabentus, and the Pastor Theodorus
van Gogh

May 12, 1873–May 1875
Vincent works as an assistant in the Paris headquarters of Goupil & Cie.; transfers to the London branch at the end of May. Hopeless love for his landlady's daughter Eugenie Loyer (1854-1911). Works as a replacement in the Paris headquarters during a short period in November 1874, leaves for London again after Christmas, and returns to Paris at the end of May.

1875-1876
Assistant in the Paris art dealership Boussod & Valadon (successors to Goupil & Cie.); dismissed on March 30, 1876. Makes occasional short visits home, now residing in Etten, Breda. Intensive study of the Bible, obsessive piety.

March 30, 1853
Vincent Willem van Gogh is born in Zundert (in Brabant). He is the second of the seven children of the Protestant Pastor Theodorus van Gogh (1822-85) and his wife Anna Cornelius Garbentus (1819-1907).

May 1, 1857
Birth of his brother Theo van Gogh (died January 25, 1891 in Utrecht).

July 30, 1869
Vincent starts his apprenticeship with the art dealers Goupil & Cie. in The Hague.

January 1, 1873
Theo van Gogh becomes an apprentice in the Brussels branch of Goupil & Cie.

April–December 1876
Sojourn in England as private tutor for French, German and Arithmetic, and as lay preacher; first in Ramsgate, then Isleworth and other London suburbs. Returns to Etten for Christmas.

1861-1868
Is enrolled in the local village school in Zundert (until summer 1862), then takes private lessons (until October 1864). Becomes boarder at the private school owned by Jan Provily in Zevenbergen (until August 1866), then a boarder at the state maintained King Wilhelm II middle school in Tilburg (until 1868). Returns home.

March 16, 1862
His sister Wilhelmien (Wil) van Gogh is born (died 1941).

The house in Zundert where Vincent was born

*The art dealers Goupil & Cie.
in The Hague*

Below:
Vincent at 13 years of age

Bottom right:
Vincent van Gogh, 1872

January 1877–October 1880
Vincent completes time as assis-
tant at the booksellers Blussé &
Van Braam in Dordrecht (until
May 1877), then moves to
Amsterdam in order to gain
qualifications to enter university
to study theology. At the end of
August, breaks off private studies
in Amsterdam and embarks on
training at the Evangelical Col-
lege in Laeken near Brussels.
Fails the final examination and
moves to the Belgian mining
area of Borinage at the begin-
ning of December. Takes up
temporary post for nine months
as a missionary in the District of
Wasmes. Stays on in Borinage,
although turned down for per-
manent employment, and stud-
ies drawing with the intention of
becoming an artist. Theo van
Gogh, working for Boussod &
Valadon in Paris, starts providing

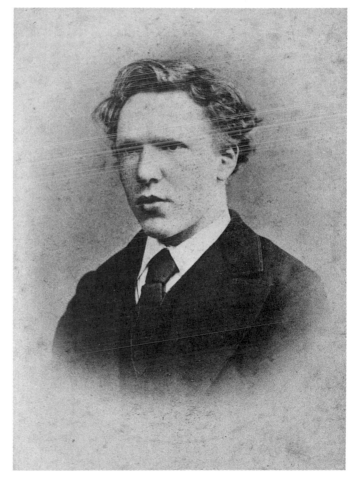

financial support for his brother, who is receiving money from his father. Vincent moves to Brussels in October 1880 and enrolls for a beginners' course at the Academy.

1881
From April onwards draws at his parents' home in Etten. Unrequited love for his widowed cousin Kee Vos (1846-1918).

1882-1883
Moves into a studio in The Hague. The leading painter Anton Mauve (1838-88), a distant relative, encourages him to work in oils there. An uncle, the art dealer Cornelius van Gogh, orders 20 drawings: views of The Hague. Cohabitation with the prostitute Clasina Maria ("Sien") Hoornik (1850-1904) is prevented by his family. Lives in the province of Drente from September until December 1883.

Po rtrait of Van Gogh's Father, *mixed media, 1881*

The artist's mother in 1884

1884-1885
Vincent works at his parents' home, now in Nuenen. Completes around 200 tonally expressive oil paintings by the end of November, including his first masterpiece, *The Potato Eaters* (April 1885). Works on six decorative pictures for the Eindhoven goldsmith Charles Hermans (1838-1934). Tutor to the Eind-

hoven tanner and amateur painter Anton Kersemakers (1846-1926). His neighbor Margot Begemann (1841-1907), having fallen in love with Vincent, attempts suicide. First exhibition of pictures in two shop windows of the paint dealer Leurs in The Hague (August 1885).

March 26, 1885
Vincent's father dies after a stroke.

November 1885–February 1886
Vincent leaves on November 24, 1885, for Antwerp for some weeks. First reference in his letters to Japanese woodcuts. In mid-January he enrolls in the Academy of Art, and becomes friends with fellow student Horace Mann Livens (1862-1936), who makes a portrait of him.

March 1886–February 1888
Arrives unannounced at Theo's home in Paris. Studies (in either spring or autumn 1886) for three

Theo van Gogh, ca. 1886

Portrait of Theo van Gogh, *crayon, 1886-87*

months in the private studio of the salon artist Fernand Cormon (1845-1924). Meets, amongst others, the Post-Impressionist painters Henri de Toulouse-Lautrec (1864-1901), Emile Bernard (1868-1941), Paul Signac (1863-1935), Georges Seurat (1859-91), and John Russell (1858-1931). In Paris also meets Paul Gauguin (1848-1903) and the Impressionists Camille Pissarro (1831-1903) and Edgar Degas (1834-1917). Vincent paints in the style of the Impressionists and Pointillists, the tones in his palette becoming lighter, and at the same time is much influenced by Japanese woodcuts. Completes over 300 drawings and pictures, including 29 self-portraits. First sales at knock-down prices through the paint dealer Julien ("Père") Tanguy (1825-94); first group exhibition in restaurants and in a theatre; last documented love affair with the gastronome Agostina Segatori (1841-1910).

February 20, 1888
Arrives in Arles and resides in Hôtel-Restaurant Carrel, 30, rue Cavalerie.

March–May 1888
Paints the Langlois Drawbridge, a series of Orchard pictures and makes large drawings. Acquaintanceship with the fellow painters Christian Mourier-Petersen (1858-1945) and Dodge MacKnight (1860-1950). Following disagreement about the hotel's charges, moves into the Café de la Gare (30, place Lamartine). Rents four rooms in the Yellow House at 2, place Lamartine, as a studio.

May 30–June 3, 1888
Travels by mail coach to Les-Saintes-Maries-de-la-Mer. Returns with three paintings and eight drawings.

June–October 1888
Trip to Tarascon (June 7-8). Meets the Belgian painter Eugène Boch (1855-1941), Second Lieutenant Paul-Eugène Milliet of the Zouaves, and the postman Joseph Roulin (1841-1903), of whom he later makes portraits. Paul Gauguin accepts an invitation to come to Arles (June 29). Vincent works on his harvest pictures, including *Sower with Setting Sun* (end of June). Late

Self-Portrait, *oil on canvas, 1889. Musée d'Orsay, Paris*

Gottfried Helnwein, Vincent van Gogh *was commissioned by the art magazine ART in 1992.*
© G. Helnwein, Burgbrohl

summer and autumn see the completion of the most famous works done in Arles: the series of *Sunflowers,* the *Night Café,* the *Café Terrace at Night,* the *Starry Night* and the *Bedroom* as well as a group of his best portraits. Spends his first night in the now furnished Yellow House on September 17.

Vincent's home in Arles: the Yellow House, ca. 1930

Dr. Paul Gachet, Van Gogh's doctor in Auvers

October 23, 1888
Paul Gauguin arrives in Arles.

November–December 1888
The two friends paint together in Arles; trip to Montpellier: discussion there looking at works by Delacroix and Courbet (December 17-18).

December 23, 1888
Van Gogh suffers a breakdown; self-mutilation after a disagreement with Gauguin. Vincent takes the severed ear with him to a brothel.

December 24, 1888–January 8, 1889
Vincent is found by the police in the Yellow House and is taken to the hospital. Theo van Gogh, informed by Gauguin, comes to Arles, and returns to Paris on December 26 with Gauguin. January 7, 1889: discharged from the hospital; January 8: Vincent starts to paint again.

February 7, 1889
Renewed attack, second stay in the hospital (until February 17).

February 18, 1889
Citizens' petition against Van Gogh on the grounds of alleged immoral conduct. Confined to the hospital under police orders. He is visited by the painter Paul Signac on March 23.

April 17, 1889
Theo van Gogh marries the Dutchwoman Johanna Gesina Bonger (1862-1925).

May 8, 1889–May 16, 1890
Vincent admits himself to the Saint-Paul-de-Mausole Sanatorium in Saint-Rémy de Provence. He suffers four serious relapses and is unable to paint during 15 of his 53 weeks there. Despite this, he completes nearly 300 drawings and paintings, including the *Irises* and the *Starry Night*. Invitation to exhibit with the group *Les XX* in Brussels, leading to the first and only sale of a work at the going rate in the art market of 400 francs (*Red Vineyard*, 1888). January 1890: the critic Albert Aurier (*Mercure de France*, Paris) publishes the first article about Vincent.

May 17–July 29, 1890
Having left the sanatorium, Vincent spends three days with his brother and sister-in-law in Paris. He moves to Auvers-sur-Oise (Pension Ravoux, place de la Mairie), and completes about 60 drawings and 82 oil paintings in ten weeks, including portraits of his physician there, Paul Gachet (1828-1909), and the *Wheatfield with Crows*. He also paints Gachet's 21-year-old daughter Marguerite, with whom he is said to be in love. June 8: visit by Theo with his wife and their son Vincent, born in January in Auvers. July 6: at Theo's home in Paris. July 27: Vincent injures himself with a shot from a pistol. July 29: Vincent dies with Theo by him.

January 21, 1891
Death of Theo van Gogh.

The room in Auvers in which Van Gogh died

Notes

1 Roland Dorn, *Vincent van Gogh und die Moderne*, exh. cat. (Essen, 1990), p. 37.

2 Ibid., p. 36

3 Zouaves: special unit in the French Army, largely deployed in the colonies and made up of Algerians until 1839

4 Uwe M. Schneede, *Van Gogh in Arles* (Munich, 1989), p. 9

5 Ibid.

6 Quoted in Ralph E. Shikes and Paula Harper, *Pissarro: His Life and Work* (London, Melbourne and New York, 1980), p. 245

7 John Rewald, *Von Van Gogh bis Gauguin* (Cologne, 1987), p. 16

8 The firm had been sold.

9 Pre-Raphaelites: a society of English painters (The Pre-Raphaelite Brotherhood) founded in 1848 by Dante Gabriel Rossetti, Holman Hunt and John Everett Millais with tendencies towards religious mystification going back in the spirit of Romanticism to "Raphael's precursors" in the fifteenth century (Fritz Erpel).

10 The art historian Jan Hulsker is of the opinion that Van Gogh had at that point in fact already completed nine pictures because the almond blossom still life exists in two versions

11 Ronald Pickvance, *Van Gogh in Arles*, exh. cat. (New York, Metropolitan Museum of Art, 1984), p. 45

12 Schneede, op. cit., p. 19

13 Jan Hulsker, *The Complete Van Gogh* (New York, 1980), p. 318

14 Pickvance, op. cit., p. 55

15 Meyer Schapiro, *Van Gogh* (Cologne, 1988), p. 13

16 Horst Keller, *Vincent van Gogh: In der Provence* (Munich, 1989), p. 55

17 Jan Bialostocki, "Van Gogh's Symbolik," *Stil und Ikonographie* (Dresden, 1966), p. 186

18 Dated according to: Matthias Arnold, *Vincent van Gogh: Biographie* (Munich, 1993), p. 162. Previously the date had been taken to be October 15, 1879.

19 In 1873 Van Gogh fell unhappily in love with Eugénie Loyer, the daughter of his landlady in London, and, in 1881, with his widowed cousin Kee Vos. From 1882 to 1883 he lived in The Hague with the prostitute Clasina Maria ("Sien") Hoornik, and in 1887 had an affair with the Parisian gastronome Agostina Segatori. In 1884 in Nuenen (Brabant), his neighbor Margot Begemann, 43, fell in love with Vincent, 31; when her family remonstrated with her, she took strychnine, but survived.

20 Pierre Leprohon, *Vincent van Gogh: Genie und Wahnsinn* (Munich, 1990), p. 14

21 Julius Meier-Graefe, *Entwicklungsgeschichte der modernen Kunst*, new edition (Munich, 1987), p. 635

22 By way of comparison: the postal worker Joseph-Etienne Roulin, who became a friend of Vincent's in Arles, had to manage with his wife and three children on 135 francs per month.

23 More on this in a letter to the art critic Albert Aurier (February 1890): "My part in this, now or in the future—you may take my word for it—will be no more than incidental."

24 Schapiro, op. cit., p. 72

25 Schneede, op. cit., p. 21

26 Ibid., p. 22

27 This particular passage is not to be found in *Bel Ami*, but in the novel *Yvette*.

28 "L'Homme de Bronze," September 30, 1888: "Mr. Vincent, Impressionist painter, is working at night by gaslight, as he assures us, in one of our squares."

29 Hulsker, op. cit., p. 360

30 This picture is known to us only in reproductions; the original held by the Kaiser Friedrich Museum in Magdeburg was destroyed by fire in World War II.

31 Dorn, op. cit., p. 37

32 Ibid.

33 Original destroyed by fire in 1946.

34 A second version of this, painted by Vincent van Gogh in January 1889, was bought in London at Christie's by the Yasuda of Japan for £ 24.75 million.

35 Van Gogh also copied this picture in 1889.

36 Schapiro, op. cit., p. 78

37 Roland Dorn, *Décoration. Vincent van Goghs Werkreihe für das Gelbe Haus in Arles* (Hildesheim, 1990), p. 79

38 Standard measurement used by Paris art dealers: a "picture at 30" is approximately equivalent to $36\frac{1}{4}$ x $28\frac{3}{4}$ in. (92 x 73 cm).

39 Vincent subsequently apologized to the prostitute he had frightened by taking her his ear. In a letter of February 3, 1889: "Yesterday I went to see the girl that I had gone to when I was out of my wits."

40 Schapiro, op. cit., p. 92

41 Quoted in Matthias Arnold, op. cit., p. 751

42 Ibid., p. 757

43 Ibid., p. 766

44 Ibid., p. 757

45 Medical records in Saint-Rémy as quoted by Wilfred N. Arnold in: *Vincent van Gogh—ein Leben zwischen Kreativität und Krankheit (Vincent van Gogh—a Life between Creativity and Illness* (Basel, 1993), p. 192. In his book, the Australian biochemist refutes Peyron's diagnosis as well as the hitherto accepted more modern notions of epilepsy, schizophrenia, syphilis, or even lead poisoning contracted from certain paints. Instead, his diagnosis is "AIP—acute intermittent porphyria." Vincent's sister Wil may also have had this hereditary metabolic disorder, first described in 1889, for she was admitted into a sanatorium in 1902. Theo van Gogh, who died on January 25, 1891, in a mentally unstable state—only 184 days after Vincent—also displayed, symptoms of the same condition.

Bibliography

Work catalogues, collection catalogues and correspondence

Jacob Baart de la Faille, rev. Abraham M. Hammacher et al., *The Works of Van Gogh: His Paintings and Drawings.* Amsterdam, London and New York, 1970; based on the de la Faille catalogue raisonné of 1928, rev. 1939.

Jan Hulsker, *The Complete Van Gogh: Paintings, Drawings, Sketches.* Oxford and New York, 1977; repr. New York, 1980; originally published as *Van Gogh en zijn weg.* Amsterdam, 1977; 6th rev. ed. 1989.

Ronald de Leeuw, *Van Gogh at the Van Gogh Museum.* Zwolle, 1994.

Catalogue of the 278 Works by Vincent van Gogh belonging to the Collection of the State Museum Kröller-Müller. Otterlo, 1952; latest rev., eds. Taap Bremer and Toos van Kooten, 1983.

Verzamelde brieven van Vincent van Gogh, eds. Johanna van Gogh-Bonger and J. van Gogh, 4 vols. Amsterdam and Antwerp, 1952-54; repr. 1976; this gives each letter in its original language.

The Complete Letters of Vincent van Gogh, ed. and trans. Johanna van Gogh-Bonger and C. de Dood, rev. C. de Dood, 3 vols. London, 1958; repr. 1978.

Paul Gauguin: 45 Lettres à Vincent, Théo et Jo van Gogh, ed. Douglas Cooper. The Hague and Lausanne, 1983.

Gerhard Eimer et al. eds., *Van Gogh Indices: Analytischer Schlüssel für die Schriften des Künstlers.* Frankfurt am Main, 1992.

Vincent Willem van Gogh: Briefe an Émile Bernard, Paul Gauguin, Paul Signac und Andere, ed. Hans Graber. 3rd. edn. Basel, 1938.

The Letters of Van Gogh, sel. and ed. Mark Roskill. London, 1963; latest repr. 1983.

Vincent van Gogh: Letters from Provence, sel. and int. Martin Bailey. London, 1990; repr. 1992.

Monographs and specialized studies (in alphabetical order)

Matthias Arnold, *Vincent van Gogh: Biographie.* Munich, 1993.

Matthias Arnold, *Vincent van Gogh: Werk und Wirkung.* Munich, 1995.

Wilfred Niels Arnold, *Vincent van Gogh: Chemicals, Crises, and Creativity.* Boston, 1992.

Russell Ash, *Van Gogh's Provence.* London, 1992.

Bruce Bernard, *Vincent by Himself: A Selection of His Paintings and Drawings Together with Extracts from His Letters.* London, 1985; repr. 1987.

Philip Callow, *Van Gogh: A Life.* London, 1990.

Ronald Dorn, *Décoration: Vincent van Goghs Werkreihe für das Gelbe Haus in Arles.* Hildesheim, 1990.

Fritz Erpel, *Vincent van Gogh: Lebensbilder, Lebenszeichen.* Berlin and Munich, 1989.

Fritz Erpel, *Vincent van Gogh: Die Rohrfederzeichnungen.* Berlin and Munich, 1990.

Abraham Marie Hammacher, *Van Gogh.* London, 1982.

Vojtech Jirat-Wasiutynski et al., *Vincent van Gogh's Self-Portrait Dedicated to Paul Gauguin.* Cambridge, MA, 1984.

Horst Keller, *Vincent van Gogh: In der Provence.* Munich, 1989.

Pierre Leprohon, *Vincent van Gogh.* Paris, 1988. German trans.: *Vincent van Gogh: Genie und Wahnsinn.* Munich, 1989.

Melissa McQuillan, *Van Gogh.* London, 1989.

Humberto Nagera, *Vincent van Gogh: A Psychological Study.* London, 1967.

Mark Roskill, *Van Gogh, Gauguin and the Impressionist Circle.* London, 1970.

Meyer Schapiro, *Vincent van Gogh.* New York, 1983.

W. Scherjon and J. de Gruyter, *Van Gogh's Great Period: Arles, St.-Rémy and Auvers sur Oise.* Amsterdam, 1937; adapted from the original French edition of 1932, which does not cover Arles.

Uwe M. Schneede, *Van Gogh in Arles: Paintings 1888-1889.* Munich, 1989.

David Sweetman, *The Love of Many Things: A Life of Van Gogh.* London, 1990.

Marc Edo Tralbaut, *Van Gogh: Le mal aimé.* Lausanne, 1969; English edn. *Vincent van Gogh.* London and New York, 1969.

Evert van Uitert, *Vincent van Gogh: Tekeningen.* Amsterdam, 1977; English trans. by Elizabeth Willems-Treeman: *Van Gogh Drawings.* London, 1979.

Johannes van der Wolk, *De Schetsboeken van Vincent van Gogh.* Landshoff, 1986; English trans. by Claudia Swan: *The Seven Sketchbooks of Vincent van Gogh: A Facsimile Edition.* London, 1987.

Recent exhibition catalogues (in chronological order)

Van Gogh in Arles, ed. Ronald Pickvance. Metropolitan Museum of Art, New York, 1984.

Van Gogh at Saint-Rémy and Auvers, ed. Ronald Pickvance. Metropolitan Museum of Art, New York, 1986-87. New York, 1986.

Van Gogh à Paris, ed. Françoise Cachin and Bogomila Welsh-Ovcharov. Musée d'Orsay, Paris, 1988. Paris, 1988.

Van Gogh & Millet, ed. Louis van Tilborgh, Sjraar van Heugten and Philip Conisbee et al. Amsterdam, 1988-89. Zwolle, 1988.

Vincent Van Gogh: Paintings, ed. Evert van Uitert, Louis van Tilborgh, Sjraar van Heugten. Rijksmuseum Vincent Van Gogh, Amsterdam, 1990. Amsterdam, 1990.

Vincent van Gogh: Drawings, ed. Johannes van der Wolk, Ronald Pickvance, and E. B. F. Pey. Rijksmuseum Kröller-Müller, Otterlo, 1990. Amsterdam, 1990.

Vincent van Gogh und die Moderne, ed. Ronald Dorn et al. Museum Folkwang, Essen; Rijksmuseum Vincent van Gogh, Amsterdam, 1990-91. Freren, 1990.

Van Gogh in England: Portrait of the Artist as a Young Man, ed. Martin Bailey. Barbican Art Gallery, London, 1992. London, 1992.

Important background literature (in chronological order)

Julius Meier-Graefe, *Entwicklungsgeschichte der modernen Kunst*, 2 vols. Stuttgart, 1903-04; 2nd, rev. edn. 1914, repr. 1920; 3rd rev. edn. 1924, repr. Munich, 1966; 1987. English trans. of 1st edn. by Florence Simmonds and George W. Chrystal: *Modern Art: Being a Contribution to a New System of Aesthetics*. London and New York, 1908.

John Rewald, *The History of Impressionism*. London and New York, 1946; 4th rev. edn. 1973; repr. 1980.

John Rewald, *Post-Impressionism: From Van Gogh to Gauguin*. London and New York, 1956; 3rd rev. edn. 1978.

Sven Lövgren, *The Genesis of Modernism: Seurat, Gauguin, Van Gogh and French Symbolism in the 1880s*. Stockholm and New York, 1959; rev. edn. New York, 1983.

Japonisme: Japanese Influences in French Art 1854-1910, exh. cat., ed. Gabriel Weisberg et al.; Cleveland Museum of Art, Cleveland, Ohio; The Rutgers University Art Gallery, New Brunswick, N.J.; The Walters Art Gallery, Baltimore 1975-76. Cleveland, 1976.

Post-Impressionism: Cross Currents in European Painting, exh. cat., ed. John House and MaryAnne Stevens. Royal Academy of Arts, London. London, 1979.

Belinda Thompson, *The Post Impressionists*. Oxford and New York, 1983; 2nd edn. Oxford and New York, 1990.

Thomas Parsons and Iain Gale, *Post-Impressionism: The Rise of Modern Art*. London, 1992.

List of Illustrations

Self-Portrait with Gray Felt Hat
1887-88

Oil on canvas
17 ³/₈ x 14 ³/₄ in. (44 x 37.5 cm)
F 344-JH 1353
Rijksmuseum Vincent van Gogh,
Amsterdam, Vincent van Gogh
Stiftung
page 29

Landscape with Snow 1888

Oil on canvas
19 ⁵/₈ x 23 ⁵/₈ in. (50 x 60 cm)
F 391-JH 1358
Private collection, London
page 31

Landscape with Snow 1888

Oil on canvas
15 x 18 ¹/₈ in. (38 x 46 cm)
F 290-JH 1360
The Solomon R. Guggenheim
Museum, New York, Justin K.
Thannhauser Collection
pages 32-33

Basket with Oranges 1888

Oil on canvas
17 ³/₄ x 21 ¹/₄ in. (45 x 54 cm)
F 395-JH 1363
Collection of Basil P. and Elise
Goulandris, Lausanne
page 34

A Pair of Clogs 1888

Oil on canvas
12 ³/₄ x 16 in. (32.5 x 40.5 cm)
F 607-JH 1364
Rijksmuseum Vincent van Gogh,
Amsterdam, Vincent van Gogh
Stiftung
page 34

*Blossoming Almond Branch
in a Glass* 1888

Oil on canvas
9 ¹/₂ x 7 ¹/₂ in. (24 x 19 cm)
F 393-JH 1362
Private collection, Switzerland
page 35

An Old Woman of Arles 1888

Oil on canvas
22 ⁷/₈ x 16 ³/₄ in. (58 x 42.5 cm)
F 390-JH 1357
Rijksmuseum Vincent van Gogh,
Amsterdam, Vincent van Gogh
Stiftung
page 36

*A Pork Butcher's Shop Seen from
a Window* 1888

Oil on canvas on cardboard
15 ¹/₂ x 12 ³/₄ in. (39.5 x 32.5 cm)
F 389-JH 1359
Rijksmuseum Vincent van Gogh,
Amsterdam, Vincent van Gogh
Stiftung
page 37

*Drawbridge with Carriage
(The Pont de Langlois)* 1888

Pencil, pen, and watercolor
11 ³/₄ x 11 ³/₄ in. (30 x 30 cm)
F 1480-JH 1382
Private collection
page 38

*Drawbridge and Lady with a
Parasol (The Pont de Langlois)*
1888

Oil on canvas
21 ¹/₄ x 25 ⁵/₈ in. (54 x 65 cm)
F 393-JH 1368
Rijksmuseum Kröller-Müller, Otterlo
pages 40-41

*Orchard with Apricot Trees
in Blossom* 1888

Oil on canvas
25 ³/₈ x 31 ³/₄ in. (64.5 x 80.5 cm)
F 555-JH 1380
Rijksmuseum Vincent van Gogh,
Amsterdam, Vincent van Gogh
Stiftung
page 42

Pink Peach Trees 1888

Charcoal, watercolor
18 ¹/₈ x 12 ¹/₄ in. (45.5 x 30.5 cm)
F1469-JH1384
Rijksmuseum Vincent van Gogh,
Amsterdam, Vincent van Gogh
Stiftung
page 43

Field with a Round Clipped Shrub
1888

Pen with brown and black ink
10 x 13 ⁵/₈ in. (25.5 x 34.5 cm)
F 1421-JH 1414
Rijksmuseum Vincent van Gogh,
Amsterdam, Vincent van Gogh
Stiftung
page 44

Fishing Boats on the Beach 1888

Pen and ink,
15 ¹/₂ x 21 in. (39.5 x 53.5 cm)
F 1428-JH 1458
Private collection
page 45

Still Life with Coffee Pot 1888

Oil on canvas
25 ⁵/₈ x 31 ⁷/₈ in. (65 x 81 cm)
F 410-JH 1426
Collection of Basil P. and Elise
Goulandris, Lausanne
page 47

Harvest Landscape 1888

Oil on canvas
28 ³/₄ x 36 ¹/₄ in. (73 x 92 cm)
F 412-JH 1440
Rijksmuseum Vincent van Gogh,
Amsterdam, Vincent van Gogh
Stiftung
pages 48-49

Sower with Setting Sun 1888

Oil on canvas
25 ¹/₄ x 31 ³/₄ in. (64 x 80.5 cm)
F 422-JH 1470
Rijksmuseum Kröller-Müller, Otterlo
page 51

Sower with Setting Sun 1888

Oil on canvas
12 ⁵/₈ x 15 ³/₄ in. (32 x 40 cm)
F 451-JH 1629
Rijksmuseum Vincent van Gogh,
Amsterdam, Vincent van Gogh
Stiftung
pages 52-53

*Van Gogh's House
(The Yellow House)* 1888

Pencil, pen, ink, and watercolors
10 x 12 ³/₈ in. (25.5 x 31.5 cm)
F 1413-JH 1591
Rijksmuseum Vincent van Gogh,
Amsterdam, Vincent van Gogh
Stiftung
page 57

Lieutenant Milliet 1888

Oil on canvas
23 ⁵/₈ x 19 ⁵/₈ in. (60 x 50 cm)
F 473-JH 1588
Rijksmuseum Kröller-Müller, Otterlo
page 59

*Joseph Roulin, Sitting
in a Cane Chair* 1888

Oil on canvas
32 x 25 ³/₄ in. (81.2 x 65.3 cm)
F 432-JH 1522
Museum of Fine Arts, Boston
Gift of Robert Treat Paine II
page 60

Joseph Roulin, Head 1888

Pen and ink
12 ¹/₂ x 9 ¹/₂ in. (31.8 x 24.3 cm)
F 1458-JH 1536
J. Paul Getty Museum, Malibu, CA
page 61

Portrait of Eugène Boch 1888

Oil on canvas
23 ⁵/₈ x 17 ³/₄ in. (60 x 45 cm)
F 462-JH 1574
Musée d'Orsay, Paris
On loan from Eugène Boch
Photo: Lauros, Photographie
Giraudon
page 63

Paul Gauguin
Self-Portrait 1888

Oil on canvas
17 ³/₄ x 21 ⁵/₈ in. (45 x 55 cm)
Rijksmuseum Vincent van Gogh,
Amsterdam, Vincent van Gogh
Stiftung
page 65

*La Mousmé, Sitting
in a Cane Chair* 1888

Pen and ink
12 ³/₈ x 9 ¹/₂ in. (31.5 x 24 cm)
F 1503-JH 1533
Thomas Gibson Fine Art, Ltd.,
London
page 67

*La Mousmé, Sitting
in a Cane Chair* 1888

Oil on canvas
29 ¹/₈ x 23 ⁵/₈ in. (74 x 60 cm)
F 431-JH 1519
National Gallery of Art, Washington,
D.C., Chester
Dale Collection
page 69

Portrait of Van Gogh's Mother
1888

Oil on canvas
16 x 12 ³/₄ in. (40.5 x 32.5 cm)
F 477-JH 1600
Norton Simon Museum of Art,
Pasadena, CA
page 70

*Self-Portrait with Straw Hat
and Pipe* 1888

Oil on canvas on cardboard
16 ¹/₂ x 11 ³/₄ in. (42 x 30 cm)
F 524-JH 1565
Rijksmuseum Vincent van Gogh,
Amsterdam, Vincent van Gogh
Stiftung
page 71

*Half-Length Portrait of
the Zouave Bugler* 1888

Oil on canvas
25 ⁵/₈ x 21 ¹/₄ in. (65 x 54 cm)
F 423-JH 1486
Rijksmuseum Vincent van Gogh,
Amsterdam, Vincent van Gogh
Stiftung
page 72

Zouave Sitting 1888

Oil on canvas
31 ⁷/₈ x 25 ⁵/₈ in. (81 x 65 cm)
F 424-JH 1488
Private collection
page 73

The Old Peasant Patience Escalier
1888

Oil on canvas
27 ¹/₈ x 22 in. (69 x 56 cm)
F 444-JH 1563
Private collection
page 75

The Night Café 1888

Oil on canvas
27 ¹/₂ x 35 in. (70 x 89 cm)
F 463-JH 1575
Yale University Art Gallery, New
Haven, CT, Bequest of Stephen C.
Clark, BA, 1903
page 77

The Dance Hall in Arles 1888

Oil on canvas
25 ³/₄ x 31 ⁷/₈ in. (65 x 81 cm)
F 547-JH 1652
Musée d'Orsay, Paris
pages 78-79

Café Terrace at Night 1888

Pen and ink
24 ³/₈ x 18 ¹/₂ in. (62 x 47 cm)
F 1519-JH 1579
Dallas Museum of Fine Arts,
The Wendy and Emery Reves
Collection
page 80

Café Terrace at Night 1888

Oil on canvas
31 ⁷/₈ x 25 ³/₄ in. (81 x 65.5 cm)
F 467-JH 1580
Rijksmuseum Kröller-Müller, Otterlo
page 81

*The Starry Night (Starry Night
by the Rhône)* 1888

Oil on canvas
28 ¹/₂ x 36 ¹/₄ in. (72.5 x 92 cm)
F 474-JH 1592
Musée d'Orsay, Paris
pages 82-83

The Starry Night 1889

Oil on canvas
29 x 36 ¹/₄ in. (73.7 x 92.1 cm)
F 612-JH 1731
Museum of Modern Art, New York
On loan from Lillie P. Bliss, 1941
page 85

The Tarascon Stagecoach 1888

Oil on canvas
28 ³/₈ x 36 ¹/₄ in. (72 x 92 cm)
F 478a-JH 1605
The Henry and Rose Pearlman
Foundation, New York
page 86

*The Painter on the Road
to Tarascon* 1888

Oil on canvas
18 ⁷/₈ x 17 ³/₈ in. (48 x 44 cm)
F 448-JH 1491
Former Kaiser-Friedrich-Museum,
Magdeburg (burnt down during
World War II)
page 87